Frank Clarke

Frank Clarke's
PAINTBOX

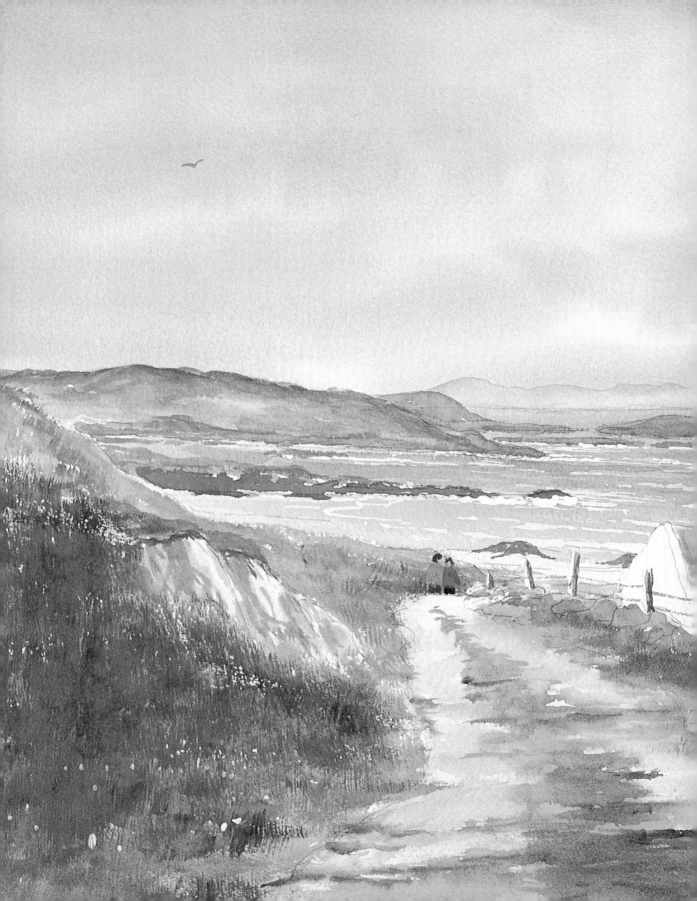

Frank Clarke's
PAINTBOX

Frank Clarke

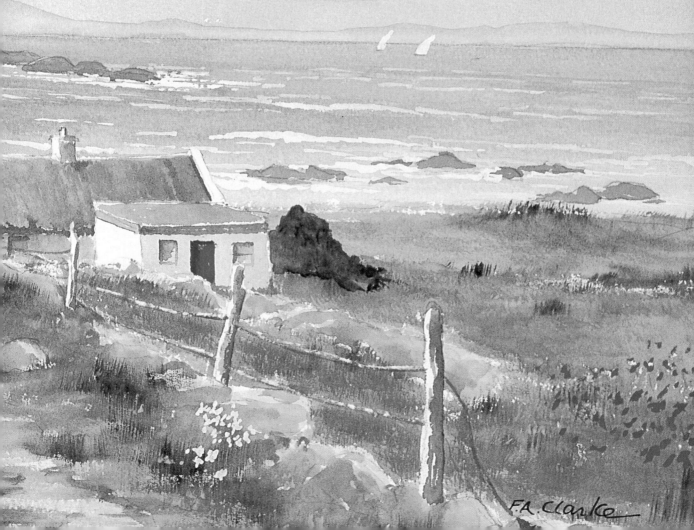

F.A.Clarke

The fact is that only 3% of people paint. The other 97% might like to, but when asked they usually reply 'I can't paint, I can't even draw a straight line!'.

Well, this book is dedicated to them.

My sincere thanks to Nicola Copeland, without whose belief in me this book would never have been born; and to my two guardian angels, Charlotte Lochhead and Isobel Gillan, who did all the hard work and guided me gently but firmly through the pages – I have learned that the phrase 'that might be nice' is the female for 'do it!'. To my wife, Peg, who now realizes that the word 'retirement' means 'get up and go'. And to Jennifer who typed up my original scrawl; Jimmy, my driving force; to everyone at Winsor & Newton for all their help; and last but by no means least, to all the people who took the time to write to me from every corner of the globe.

This book accompanies the television series *The Arts and Crafts Show* featuring *Frank Clarke's Paintbox* which was produced by Mentorn Barraclough Carey North in association with the BBC.
Executive Producer: Fiona Pitcher
Series Producer: Maggie Sutcliffe

Commissioning Editor: Nicola Copeland
Project Editor: Charlotte Lochhead
Designer: Isobel Gillan

ISBN 0 563 38466 2

First published in Great Britain in 1998
Published by BBC Worldwide Ltd
Woodlands, 80 Wood Lane, London W12 0TT

Set in Caslon and Gill Sans by BBC Worldwide Ltd
Printed and bound in France by Imprimerie Pollina S.A., Luçon, France
Colour separations by Imprimerie Pollina S.A.
Cover printed by Imprimerie Pollina S.A.

Contents

About the author

Frank Clarke was born in Dublin and after starting working life as a radio officer (though never going to sea!) he later became a dress designer for his family's clothing business. His interest in property development led to a company directorship for a large property company, but at the age of 38 Frank retired to try his hand at painting.

Despite being told by an art teacher that he didn't have 'the gift', and realizing that there was no real help available from art instruction books or classes for the complete beginner, Frank set out to rectify the situation. He taught himself how to paint and by doing so he developed his unique teaching method. The next step was obvious ... teach painting classes for beginners. The success of his teaching methods led to the publication, in Ireland, of four bestselling books and the making of over 200 television programmes, which are transmitted on more than 200 television stations worldwide. He has produced teaching videos and created his own painting materials and equipment company – Simply Painting.

After several years of Frank's 'retirement', his wife Peg realized there was no chance of him slowing down. She has now joined him as he travels worldwide teaching thousands of budding artists each year. He feels he is only 'scratching the surface' in showing people that painting is not difficult and he has a passionate (and proven) belief that anyone can paint ... and that art is for everyone.

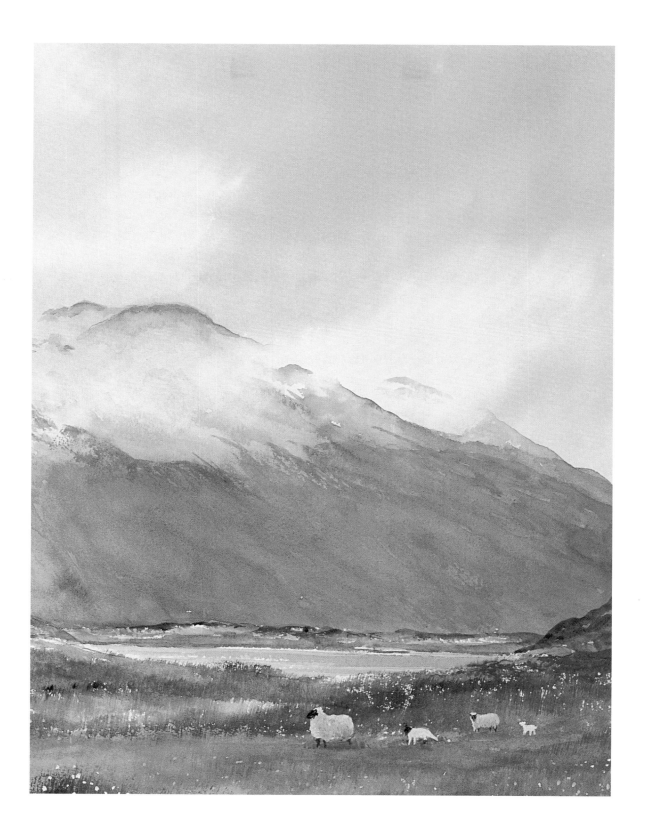

Introduction

When I started this wonderful hobby of painting I had no previous knowledge, and I am going to make the same assumption about you. It is my belief that most art instruction books start in the middle, missing out the vital chapters of information you need as a beginner to get started. It is my intention therefore to write those missing chapters. I will start at the very beginning – as the song says 'a very good place to start'! Painting is not difficult; we are just led to believe it is. To prove this, let me tell you how I first started to paint.

I was on holiday with my family in Ireland – funny how it always seems to rain when you are on holiday – and I was looking around for something to do when I saw a picture of (would you believe it) Winston Churchill, painting in his garden. He looked very content, so I decided I'd like to give it a go. I headed for the nearest town and purchased some paints and brushes.

Then I painted my first painting – a forest scene. It was copied from a picture on a calendar I found hanging on the wall. Although it was no masterpiece, and looked a little grey, I enjoyed the experience and found it totally absorbing. There and then I made a vow to join a painting class when I returned home, to try to learn the rudiments of painting. 'There must be classes for complete beginners like me,' I thought. However, that's where my troubles started.

I had no problem finding an art class which said 'Beginners Welcome'; the problem was that only half of the students really *were* complete beginners. The other half had attended many different art courses and said as much, so the teacher started the first lesson with the belief that we all had a basic knowledge of how to paint. He started to teach from the middle of the book!

Like all the other *real* beginners, I had hidden myself at the rear of the class and the first thing I noticed was that the more advanced artists

had congregated at the front. That first class, the teacher asked us to paint what we 'felt'. I 'felt' nothing artistic, so I am afraid I resorted to the best-known pastime of every beginner offered no help, and began messing with my paint and 'mud making'. After two hours the teacher came around to give his criticism of our efforts. When he got to the end of the class, where I was sitting, he just made some animated noises then returned to the front of the class and told us he would see us next week. This went on for some weeks and I noticed that the class soon shrank from twenty students to twelve, all of whom, with the exception of myself, were excellent painters. I began to feel really like a duck out of water and it seemed to me that if I could paint *already,* classes would be a wonderful pastime, but as I had come to *learn* it seemed nothing but frustrating. No one was prepared to show me the very basics.

With this in mind and realizing the basics were what I needed, I searched unsuccessfully to try to find what I wanted – a teacher who was prepared to start at the beginning. Someone who believed that being artistic and being able to paint were not God-given gifts, but were things that could be taught, if the student has the desire to learn. Not finding a teacher and being an obstinate beast, I concluded I would have to work out what the basics were and educate myself. I started at the beginning, keeping it simple and practising, and I found I was making rapid progress as well as enjoying my painting.

It is probable that many budding artists have fallen by the wayside, given up because they just couldn't get started and grasp the basics they need to paint confidently. Many students who come to my classes tell a very similar story to my own and, being ever mindful of this problem, I will make you this promise: I will start from the very beginning and if you follow my lead you will learn to paint. I should also let you know that I have never had a failure!

Painting is a desire not a gift. Some people find it easier than others, as with every other hobby, but it does seem that it is only in painting that it is considered necessary to be a genius before you can even start. People feel that they have to produce a masterpiece with their first attempt. I think that's nonsense. Could you imagine if all hobbies adopted the same guidelines of having to be an expert before you began? Golf courses would be empty, so would tennis courts; no

one would swim or knit or make pottery. What a world that would be – there would be no leisure pastimes. If only the best were considered suitable … how would anyone become the best – or greatest – without practice? It is probably fair to say that the world's greatest artist has probably never painted a picture; neither has the world's greatest racing driver ever driven round the circuit. Why? Because they have never even tried!

Painting is so easy and you don't need to be a genius to try it. All you need is the desire to paint. Kids love to paint because they have no fear of it and no one has told them that they *can't* paint. It was Picasso who once said, 'It has taken me thirty years to learn to paint like a child'. Anyone can do it, so give it a go. I can teach you and, apart from the wonderful paintings you will produce, you will find that you are never lonely with a paintbrush. Painting is the most joyful of hobbies and very therapeutic, too. One of the many amazing by-products of learning to paint is that you

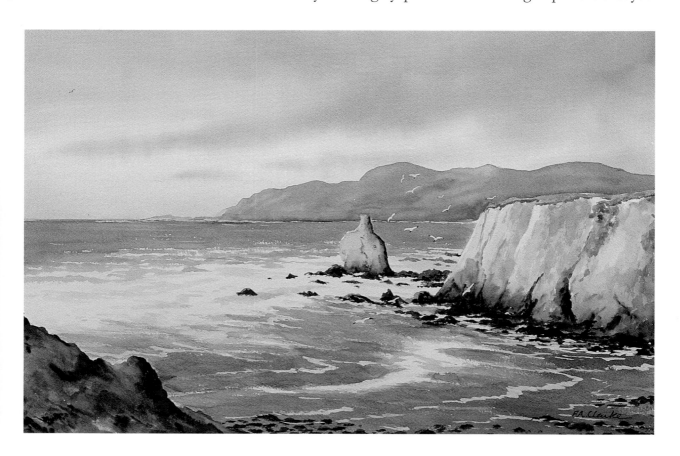

will begin to see nature for the first time through the eye of an artist. Another is that sometimes what starts out as your hobby may end up earning you some money!

If I appear to be waffling it is because I find myself getting so enthusiastic about painting and because I feel I must get you to believe in yourself before you start. So much nonsense has been written (and spoken) about how difficult painting is and this makes people believe their own words 'I can't paint, I can't even draw a straight line'.

How often have I heard those words? When I hold one of my one-day beginner's classes I always ask how many of us can't paint and up go the hands. My reply is that they (and you, if your hand is up now) are wrong. We can all paint, it's just that some of us have not yet been shown how to start. You would be amazed at the joy and disbelief on those beginners' faces at the end of the class when they see their first effort framed. Students often ring me some days later to tell me that when they took home their picture and showed it to family and friends, the first reaction was 'You didn't do that!'.

They *did* and you *can!* You can learn. All I ask is that, to get the best results from this book, you read at least up to the end of the first lesson (page 32) before you start. Always read the steps through before you get underway painting each picture, too. It won't take long to read the introductory chapters – they aren't missing from this instruction book! – and I promise, if you do, you will have no difficulty in following the simple step-by-step lessons and learning how to paint. Remember ... I have never had a failure.

Frank Clarke

Before we start ...
a few questions answered

WHY USE WATERCOLOUR PAINT?

I use watercolours to paint all the pictures in this book. Watercolours are often considered the most difficult of all painting mediums to use but I find the reverse to be the case. The reasons are because they are:

- easy to mix
- easy to apply
- quick-drying – you don't have to wait hours before you can paint the next part of your picture
- relatively inexpensive to buy
- good value – because you use so little, they last for ages
- clean to use – they don't stain your clothes
- non-toxic – safe for children to use
- you can use them anywhere – in bed if you are ill or outdoors ... and I even paint on aircraft
- easy to transport – and lightweight ... I've never paid excess baggage yet!

Far from being difficult, it seems to me that watercolours are full of advantages and once you learn how to paint with them, you can then move on to use any other medium – oil, acrylic, gouache, etc, without difficulty. The reverse is not the case. (If you don't believe me ask any oil painter.)

Now that we are convinced that watercolours are the best starting paint, let me give you a short history of them ... in case you're interested in the background.

WHAT'S THE HISTORY OF WATERCOLOUR PAINTING?

Watercolour painting has had many ups and downs in popularity. The paint is made from natural pigment mixed with a water-soluble gum to bind it, and for some time it was believed that painting with it began in England in the early 1700s. However, the Egyptians used a form of watercolour paint over 3500 years ago, and monks in Ireland in AD 800 to 600 also used it to illustrate the famous *Book of Kells* and many other early Irish manuscripts. However, watercolours declined in popularity as oil paints were considered a more durable medium. Watercolours became more of an aid to artists, who used them to colour sketches which were later turned into oil paintings. In the later 1700s watercolours came into their own when a man called Dr Thomas Monro founded a studio at his house in London to encourage young watercolour artists. He patronized and encouraged many artists, among them a young man called William Turner. Turner's watercolour work became legendary – landmark even – in reviving the popularity of watercolour painting. The rest, as they say, is history … but at least you can now impress your friends with your watercolour history as well as your painting!

Getting organized

Watercolours, brushes, paper and all the materials you need to start painting can be bought from any good art shop.

PAINTS

Watercolours are available in pans or tubes. Pans are hard blocks of paint, which are softened with water. You will probably remember them being in the paint boxes you were given as a child. I recommend painting with tubes though, because the paint is ready to use directly from the tube.

Watercolours are made by a variety of manufacturers. There are two different qualities of tube paint – student and artist. I suggest you use student quality watercolours as they are much cheaper and can be just as permanent as artist quality paint. (You can check this for yourself by looking for up to three little stars on the side of the tube – the more stars there are, the more permanent the paint colour.) However enough about that, I am beginning to sound like my first art teacher!

For the purpose of this book I have used the Winsor & Newton Cotman colour range and here are the 8 basic colours we need:

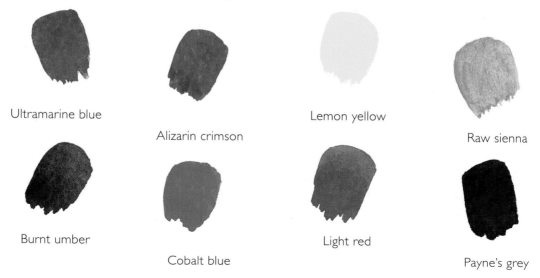

Ultramarine blue

Alizarin crimson

Lemon yellow

Raw sienna

Burnt umber

Cobalt blue

Light red

Payne's grey

I also use one other tube of paint – it is called White (permanent white) gouache. It is a white opaque paint (you can see it when it's on the paper, unlike transparent paint, which you can see through). Gouache has many uses, and I will explain these as we go through the lessons.

Beware of well-meaning friends who may present you with a generously large box of paints containing every colour under the sun. My advice would be to thank them politely, but to only use the colours I have recommended. Seriously, too many colours can confuse a beginner. The eight I have listed are the vital ones and later on you will see that they can be used to create all the colours you'll need. Also, don't be tempted by bargain basement paint (you know, the twenty tubes *really* cheap) as it just won't mix properly.

BRUSHES

To start watercolour painting you will need three brushes.

- **Large 1½-inch (38-mm) brush.** This flat brush is our workhorse and allows us to paint large areas rapidly. This is vital to beginners in watercolour painting as it stops us fiddling about. The brush should be made of goathair and is often called a hake brush, but if you can't get the recommended brush that's no excuse not to start. Any large goathair hake or watercolour synthetic brush will do. As you will find out for yourself painting is always about improvising, but it is of course easier to work with the recommended materials.

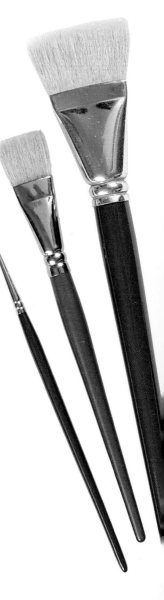

- **Small ¾-inch (19-mm) brush.** Good for painting smaller areas, this flat brush is also best when made of goathair, and it is still large enough to stop us fiddling and getting too bogged down with detail.

- **No.3 rigger.** This is a round, long-haired, synthetic-bristled brush which we use for drawing fine lines and details like my flying bird. (When I started to paint the only animation I could put into my pictures was a bird in flight. It became a habit and now every picture I paint has my pal the bird in the corner. I suppose you could say it's my trademark.)

PAPER

Watercolour paper comes in many different surfaces and thicknesses.

There are three main paper surfaces, which are hot pressed, cold pressed and rough. Sorry to sound technical, but you have to know what to ask for when you enter the 'forbidden zone'. That's what I used to call the art shop when I first started to paint because on my first trip there I was too shy to ask for help. I ended up buying a mixture of materials meant for watercolour, acrylic and oil painting. The atmosphere is always so hushed in art shops, and there is so much equipment we haven't seen before that it's a bit like an alien world. I once suggested to a store manager that all art materials should be stamped with the kind of painting they are to be used for. I was told there was no need. I wonder? So many of my students have made similar mistakes, arriving for their first class with heaps of brushes and tubes of paint, that we can't all be wrong!

So what is the difference between hot pressed, cold pressed and rough paper?

- **Hot pressed paper** has a very smooth surface.

- **Cold pressed paper** has a grain on the surface and is the most used watercolour paper. I would advise you to start to paint using cold pressed paper. By the way, cold pressed paper can often be given other names like 'medium' or 'not' paper, so don't be confused by this.

- **Rough paper** is exactly what its name implies. It has a rough surface. Because of this your brush jumps up and down across the paper and the rough finish can give a nice effect to your picture. It can take a little time to get used to.

All the different types of paper can be purchased in separate large sheets or in pads. The normal size of a sheet is 22 x 30 inches (559 x 762 mms) and although it is cheaper to buy paper this way, it is difficult to carry and you also have to cut it to whatever size you require. It is much easier to buy a pad of paper. Pads are sold in many different sizes ranging from about 5 x 8 inches (125 x 200 mms) up to 20 x 24 inches (510 x 610 mms).

I use a pad of 10 x 14-inch (255 x 355-mm) paper, but before you buy it you also need to be aware that watercolour paper not only comes in different sizes but also comes in different weights. Don't panic! It's fairly logical. The thicker a piece of paper is, the more it weighs. Weights of paper range from about 90lb up to 400lb per ream (or 190 to 850 grams per square metre). So, 400lb paper will be a lot thicker than 90lb paper because it weighs more – in fact it is almost cardboard!

Thick paper is more expensive so I suggest using 140lb/300gsm paper. (This is the lightest paper you can use without having to mess about soaking and stretching it. As it's not necessary for you to stretch your paper I won't bore you with the details of how to do it.) One of the advantages of watercolour paper is that you can paint on both sides, the surface is the same whichever way up it is.

So, it's simple, you need a 10 x 14-inch (255 x 355-mm) pad of 140lb/300gsm paper for all the lessons in this book.

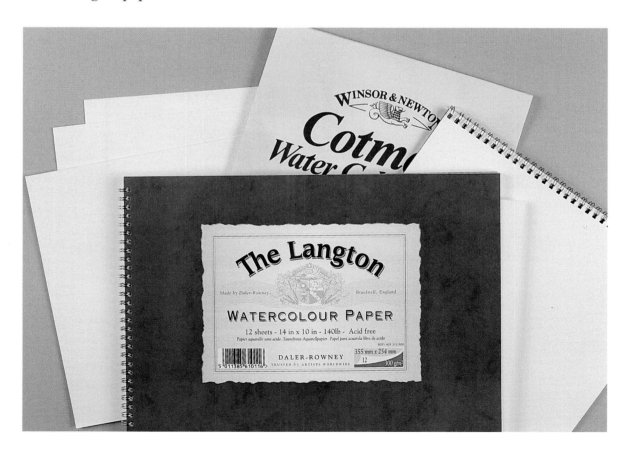

OTHER THINGS YOU'LL NEED

Before we start to paint we need some other items, most of which you can find around the house.

- A white plate or small white tray to act as a palette (to put your paint on)
- A large jar or pot for holding water (the bigger the better)
- Some old cloths to wipe your brushes on
- A pencil (H.B. is fine)
- A ruler
- An eraser
- A flat board measuring approximately 16 x 20 inches (410 x 508 mms) to fix your 10 x 14-inch paper onto. (Your board needs to be propped up by about 2½ inches (7 cms) so find a large book or something to lean it on. It is easier to paint on a slightly sloping surface and it helps control the water.)
- Masking tape for fixing the paper onto the board
- Masking fluid
- Hair dryer (if you have one, to help dry parts of your painting)

Handy tip: It is not necessary to have an easel, but if you do get one make sure it is one designed for doing watercolour painting. They are usually metal and allow you to paint almost flat, rather than upright as you would if you were painting in oil or acrylic.

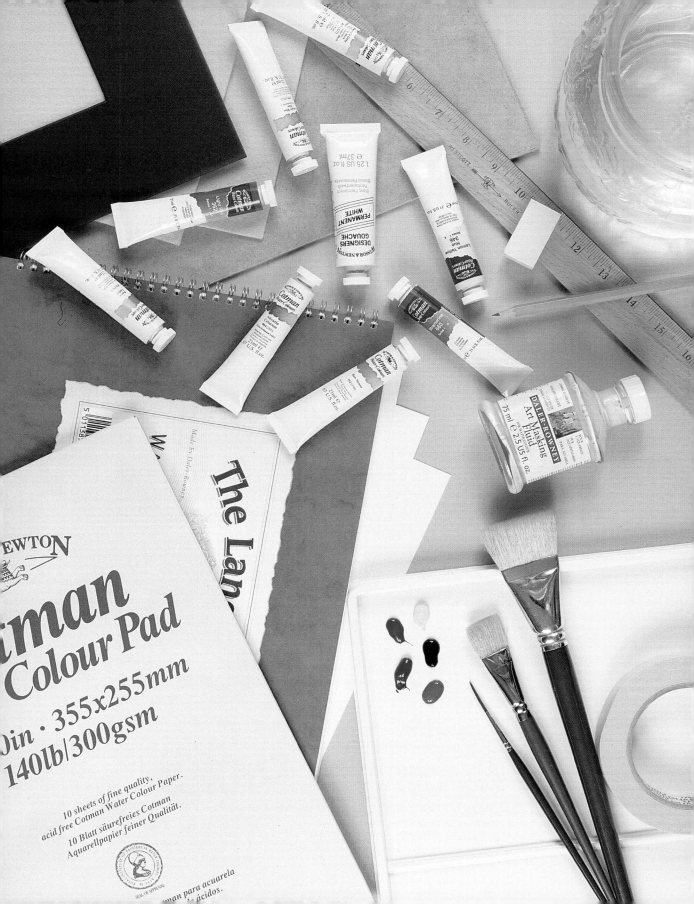

Have Some More Fun!

As well as being true – that painting *is* fun – Have Some More Fun is the unique system behind my painting concept. When I first started to give painting lessons I realized that my students were suffering from exactly the same problems I had when I started. They did not know *where* to start and, once they put the brush on the paper they had no idea what to do next. (They usually jump about the paper with their brushes like frogs jumping about in a bucket!) Because of this uncertainty I think it's fair to say most students give up before they even get started.

It is very easy to be put off and give up when you don't know what it is you are trying to do. This, and the ingrained belief that you can't paint because you don't have the gift or talent are the main reasons that budding artists never bloom.

I found that if I simplified a landscape and broke it down into different painting stages, it was easier for a student to understand what it was they were trying to do. By painting step by step, any beginner can paint a picture at their first sitting. And, if they do this, they see for themselves that they can paint. It is vital to get people to believe they can paint and I have devised a simple, easy-to-remember system which gives a beginner the basic way forward. Have Some More Fun was that system and I will explain how it works. Once you've cracked it you will advance in leaps and bounds and your natural, but as yet unexplored, ability to paint will emerge.

It may help you to know at this stage that I have yet to meet anyone who cannot paint a picture using my Have Some More Fun system.

Have Some More Fun is simple. By dividing a picture into four distinct areas, each can be painted in turn without fear of messing up what you have already completed. The four areas are Horizon, Sky, Middleground and Foreground and to make these easy to remember I took the first letter of each word and turned them into a sentence.

HORIZON H Have

SKY S Some

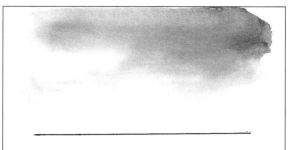

MIDDLEGROUND M More

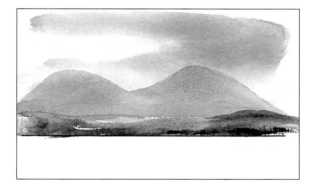

FOREGROUND F Fun

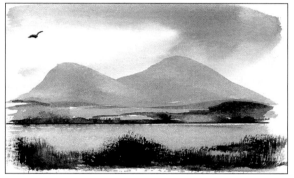

Have Some More Fun not only explains how to remember which parts there are to your picture, it also gives you the order in which you paint them. So each time you start to paint a picture you'll know to paint the Horizon first, Sky second, then do the Middleground and finish with the Foreground. It works every time so remember:

HAVE SOME MORE FUN!

USING THE BRUSHES

The question I am most often asked is 'How do I use the brushes?'. So before we commence our first painting let me show you how to use the brushes and how to control the water and mix your paint.

Using a flat brush

Let's start with the large (1½-inch) brush. This is large and can hold lots of water which needs to be controlled. To control it you will need a mop up cloth, then:

1 Hold the brush upright and dip it into your water. Lift it out and rest the body of the brush on your folded mop up cloth, keeping the tip away from the cloth. You want to soak up the excess water from the body of the brush while still keeping the tips of the bristles wet. Don't dry the tip.

Repeat this action each time you clean your brush as this controls the amount of water your brush is carrying when you put it into the paint on your palette. It is vital that you do this soak up exercise every time your brush comes out of the water. Try this action a few times before you start to paint. It will soon become automatic, every time you clean your brush.

 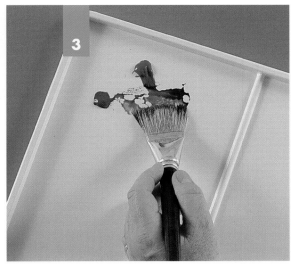

2 Using the corner of the large brush, lift some of the paint and take it to the centre of your palette. Then, keeping the brush flat, move it from left to right. This action mixes the paint with the water held in the brush hair and coats the bristles with paint.

Turn the brush over and repeat this left to right movement. You have now loaded the brush on both sides and are ready to apply the paint to your paper.

3 To mix two or more colours with a large brush, the method is the same as before. Take the first colour to the centre of your palette then pick up a little of the second colour and mix them together by moving the brush from left to right. Turn the brush over and repeat the left to right movement in order to load the mixed paint onto both sides of your brush.

When you are mixing two colours together, getting the correct colour and tone can take time. I reckon that 90% of my time is spent mixing up the correct colour (then testing it on scrap paper, adding water, etc) and only 10% is spent applying that colour to the paper!

Use the small (¾-inch) brush in the same way as the large one. One final point … never bend the bristles of the brush down onto the palette. If you do you will mess up the hair on the brush, damaging it.

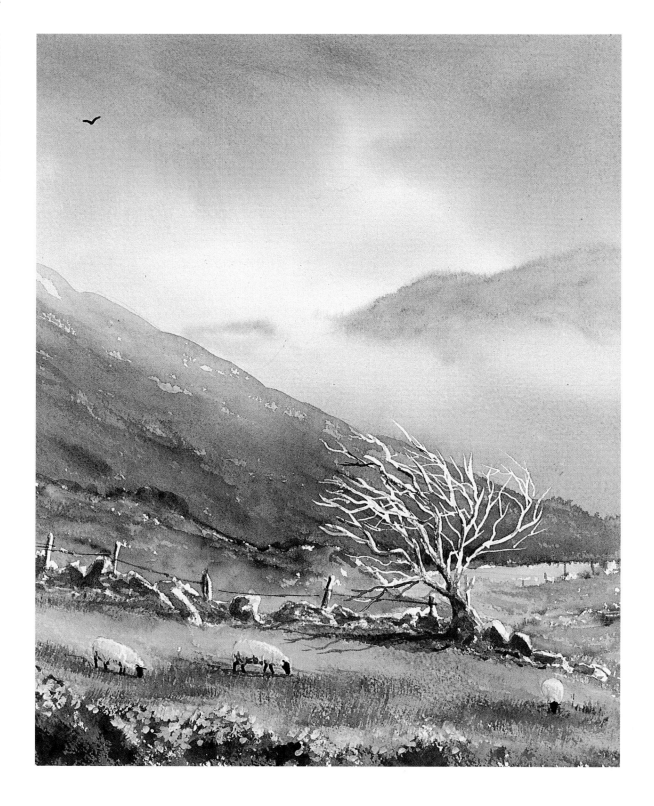

Using a rigger

1 As the no.3 rigger is a very small brush, you can use it like a pen. Hold the brush the same way you would a pen or pencil when you write your name. Dip the brush into your water and then pick up some paint and take it to the centre of your palette. Mix the water with the paint, by moving the brush from left to right, so that the paint is about the same consistency as ink.

2 Because this brush doesn't hold much water, you may have to dip it into the water several times over. Use plenty of water otherwise the brush will become clogged with lumps of paint. (An easy way to check if the paint is mixed to the right consistency is to look to see if there is solid paint on the hair of the rigger: if there is then you need to mix in some more water.)

There are other ways of using your rigger brush which I will explain as we go along. Now you know how to use your brushes, we are ready to have some fun and paint a picture.

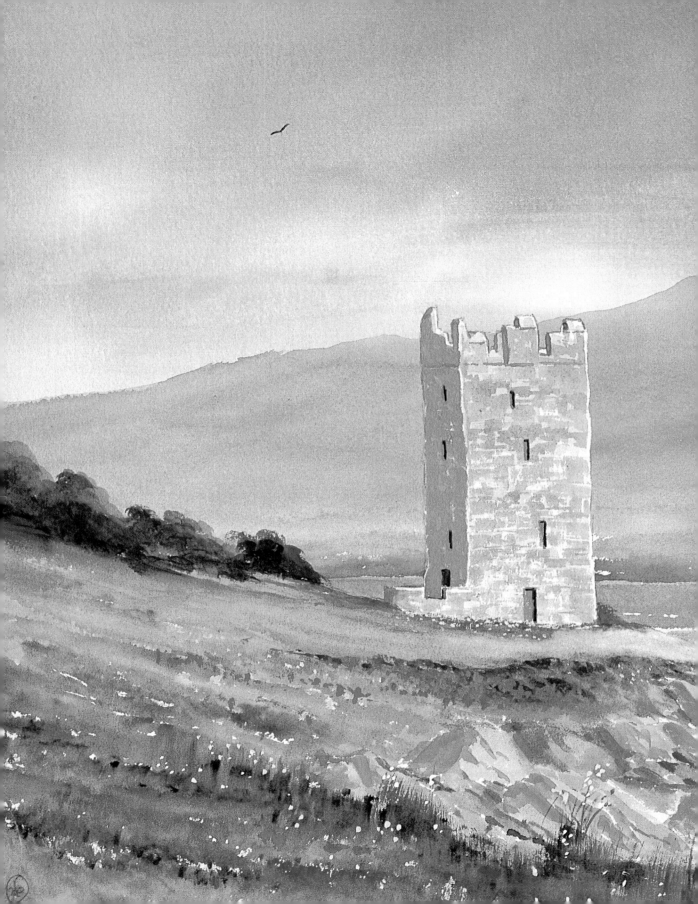

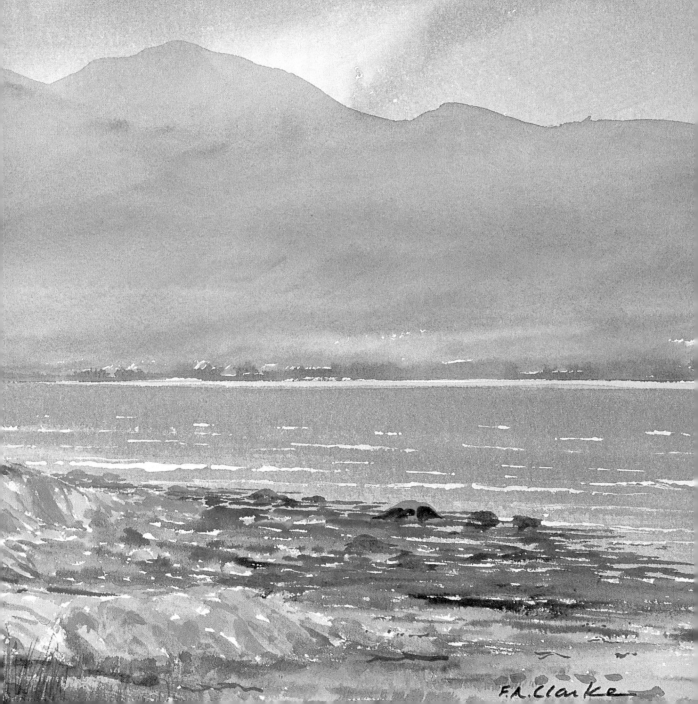

Let's paint a picture!

F.A. Clarke

mountain landscape

Our first painting (see pages 32–33) only uses one tube of paint so we don't have to worry about mixing colours. We learn about tone too – mixing in more or less water to create lighter or darker shades of colour. Read the steps through before you start.

you will need

- Paint: Burnt umber
- Brushes: your large (1½-inch) brush and no.3 rigger
- Paper: a sheet of 10 × 14-inch (255 × 355-mm) 140lb/300gsm watercolour paper
- Palette (your white plate or tray)
- Water pot
- Mop up cloths
- Pencil
- Ruler
- Eraser
- Board (16 × 20 inches (410 × 508 mms) to stick your paper on)
- Masking tape

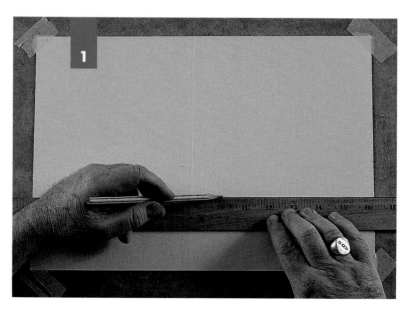

1 HORIZON Using masking tape across the corners, fix your sheet of paper lengthways onto your board. (This is 'landscape'. If the paper was upright it would be 'portrait'.) With a pencil, draw the horizon line about 3 inches (7.5 cms) up from the paper's bottom edge. Prop up the board.

Be aware that you have only two minutes to paint a sky, once you've wet the paper, so don't labour it! Squeeze out some Burnt umber onto your palette.

2 SKY Wet the large brush. Starting from the top of the page, use broad strokes to wet down to an inch above the horizon line. (Look from the side to see the sheen and make sure it's wet.)

3 Quickly mix watery Burnt umber. Paint the sky starting from the top. Leave some gaps of white cloud. Mix more paint with less water to apply another darker layer of sky. Use horizontal dabs to form sausage shapes – large ones at the top, small below. Dry this.

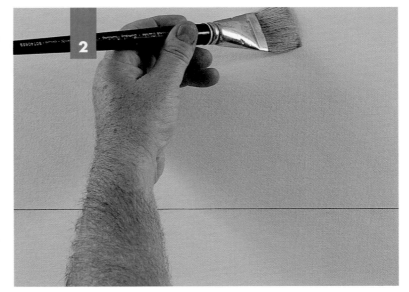

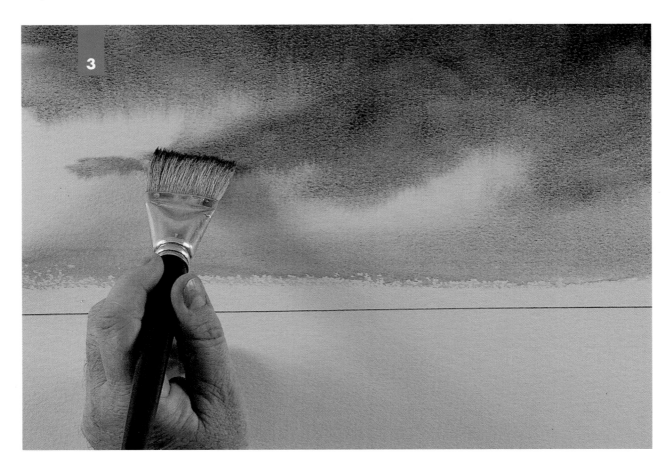

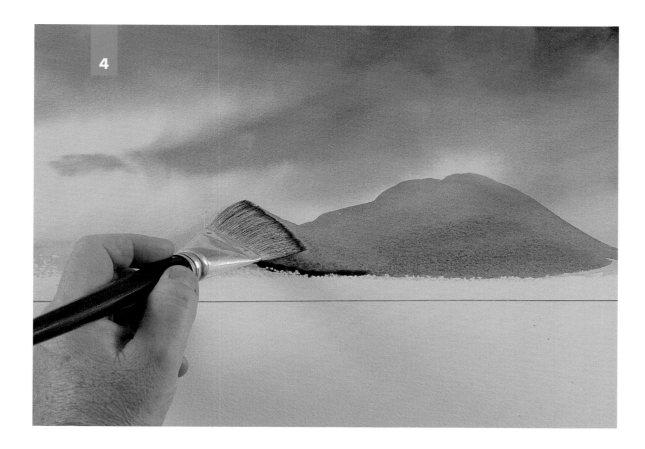

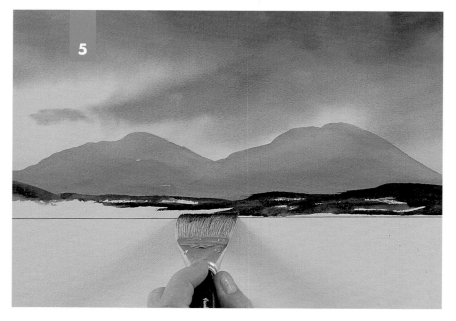

4 MIDDLEGROUND Reload your brush with paint. Keep above the horizon line and paint a wobbly 'M' for your mountains. Fill this in and let it dry. (I'm left handed so I start from the right. If it's easier, start from the left.)

5 Mix some darker paint (use less water). Dab in the lakeshore, holding the brush horizontal and upright like a chisel. Leave some white bits but don't go below the horizon line. Dab some even darker paint along the horizon line to finish the lake edge.

6 FOREGROUND Making sure the painting is dry, let's paint the lake. Make a weak mixture of paint (use lots of water) and load the large brush well. Start from one side and make a broad stroke across to the other side. Leave some white between the shore and water's edge. Sweep across again, and repeat the action to fill the foreground with water.

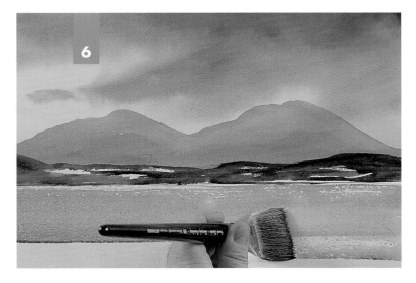

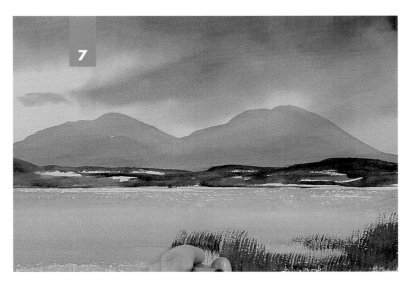

7 When the lake is dry you can paint the rushes. Dry your large brush on your cloth, then load it with almost neat paint. Using short downward strokes, form small patches of rushes. You can vary the shade of the paint slightly by adding a little water to give lighter patches here and there, but keep the brush quite dry so that the bristles splay to create the stalks of the rushes.

8 To finish off, I always paint in my little bird with a rigger brush – it's simple, just a tiny 'V'-shaped stroke to show wings in flight. Then I sign my painting with a black pen.

Congratulations! You've just created your first masterpiece.

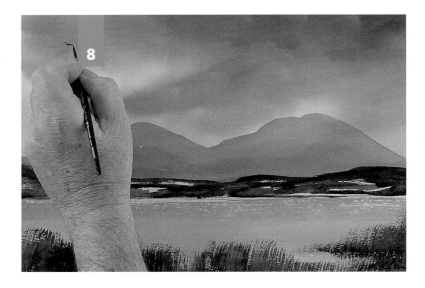

MOUNTAIN LANDSCAPE

Now frame your picture (see page 112), you will be amazed how much this improves it.

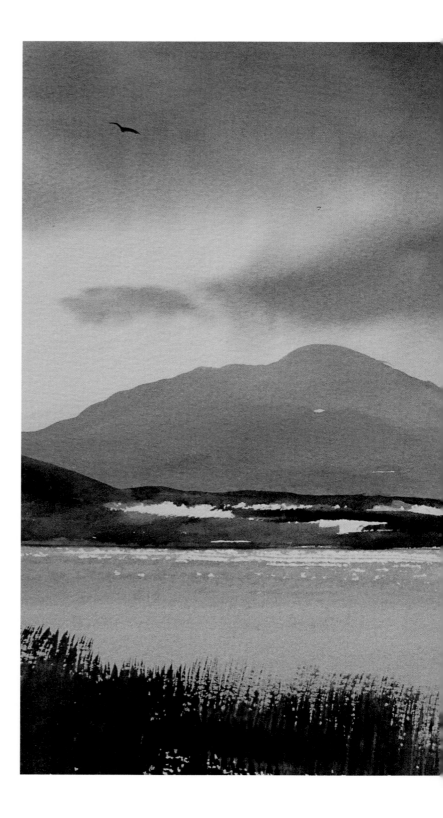

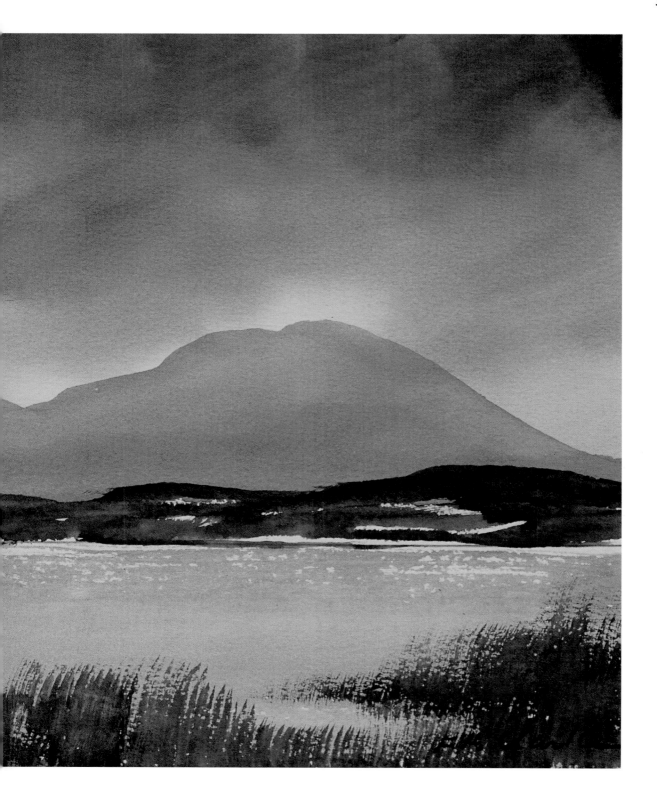

painting *people*

Now you have completed your first masterpiece. Let me show you how to put some life into your picture. It may seem that we are advancing too quickly but that's what the Have Some More Fun system allows us to do because it's so easy to learn with.

Figures are not difficult to paint if you simplify the shape of a person into something we all recognize and can draw. Using a simple shape like a carrot, painting people into a landscape scene is easy. You are probably thinking that I have taken leave of my senses at this point, but it was Paul Cézanne, the famous French impressionist, who first discovered the value of carrots in learning to draw and paint. He said 'The day is coming when a single carrot freshly observed will cause a revolution'. He was absolutely right and so, with this in mind, let's draw some carrots!

On a piece of scrap paper practice, with your rigger, drawing the outline shape of a carrot. Now fill it in. Paint a few carrots.

Next put a dot on top of some of the carrots – not too big, and leaving a small gap to represent the neck. Paint tiny, darker carrots on the remaining carrot bodies, and what have we got? Men and women!

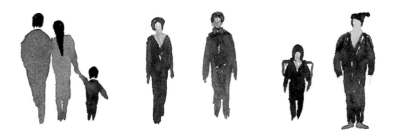

If you spend half an hour painting carrot people you will find they start to grow arms and legs. What's happening is you are starting to improvise and sketch, and the more you practise the better you will get at painting people.

So, next time you paint a landscape why not finish it off by putting in some carrot people?

Handy tip: Don't go back and paint people into the painting you have just completed. It is good to keep your first painting just as it is, as a reminder of what you can do. You know you can paint now, so practise some carrot people – maybe put them into your next landscape.

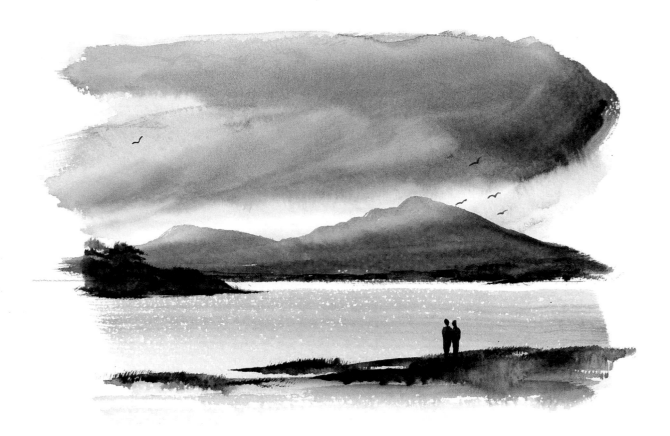

seascape

For our second painting (see pages 42–43) we are going to use colour, but don't panic! Take your time, and remember, the two-minute rule only applies to painting the sky. If you aren't happy with your sky, you can always turn the paper over and start again … all you have lost is two minutes and a bit of paint.

you will need

- Paint: Raw sienna, Cobalt blue, Light red, Burnt umber and White gouache
- Brushes: your large (1½-inch) brush, small (¾-inch) brush and no.3 rigger
- Paper: a sheet of 10 × 14-inch (255 × 355-mm) 140lb/300gsm watercolour paper
- Palette (your white plate or tray)
- Water pot
- Mop up cloths
- Pencil
- Ruler
- Eraser
- Board (16 × 20 inches (410 × 508 mms) to stick your paper on)
- Masking tape

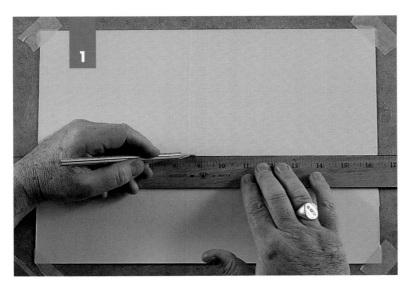

1 HORIZON Using masking tape across the corners, fix your sheet of paper lengthways onto your board. With a pencil, draw the horizon line in, just under halfway up the paper. Prop up the board.

Handy tip: Keep constantly referring to your subject (my finished seascape on page 42–43).

2 SKY Squeeze out (separately and around the edge of your palette) some Raw sienna, Cobalt blue and Light red. In the centre of the palette, make a very watery mixture of Raw sienna. You have two minutes, so using your large brush, wet the paper with this mixture, from the top down, to just above the horizon line.

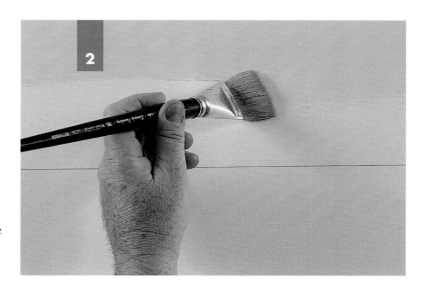

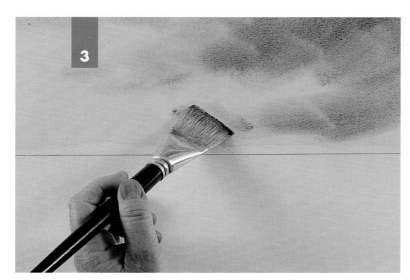

3 Quickly clean your brush and mix some Cobalt blue with water and, while the paper is still damp, apply it to create your sky. Leave some gaps for the Raw sienna clouds to show through. Remember, stay above that horizon line.

With the paper still damp, mix a tiny bit of Light red into your Cobalt blue to give a deep stormy purple shade.

4 Paint in a few dark patches or sausages (that's what I call clouds) with your brush held horizontal. (If the paint along the horizon line is running down the paper just drag your cleaned brush along it to mop up the water collecting there.) Don't fiddle or cover *all* you've already done. Dry this.

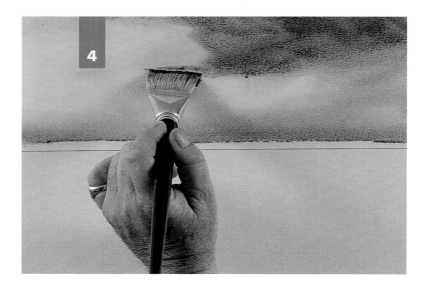

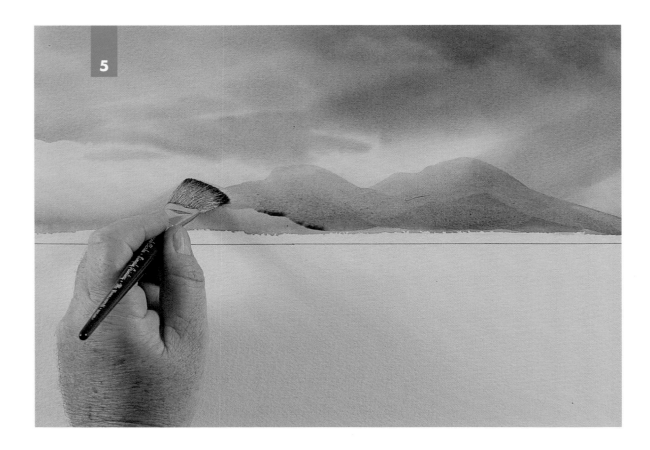

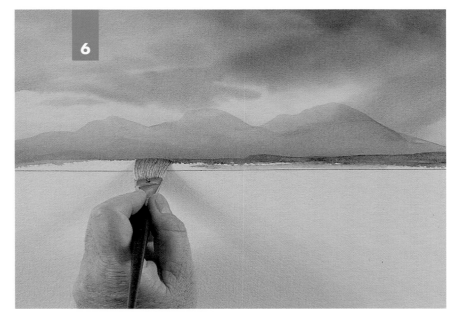

5 MIDDLEGROUND Using your small brush, mix some Cobalt blue with Light red and water (like the purple for the sky – distant things are paler than things in the foreground so don't make the colour too strong). Paint in the hills, keeping above the horizon line. Dry this.

6 Clean your brush. Mix Raw Sienna and a little Cobalt Blue with hardly any water. Dab this along, *above* the horizon line, with a horizontal brush, leaving a few specks of white.

7 FOREGROUND Still above the horizon, run across another line of just Raw sienna to create the distant beach. For the sea, with your large brush, mix watery Cobalt blue with the tiniest bit of Light red. Sweep in a broad stroke of this. (Sea only needs to be 1½ inches deep.) Dry this.

8 Mix Raw sienna with water and paint broad strokes to fill to the bottom of the page, leaving white surf between sand and sea.

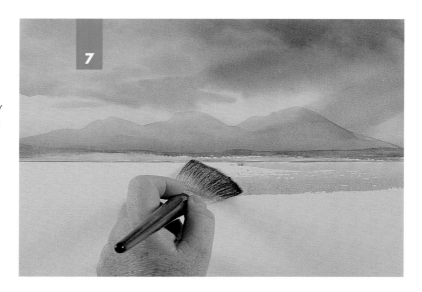

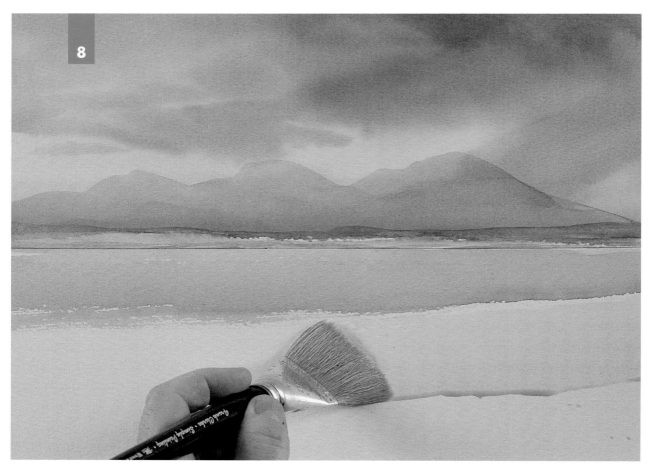

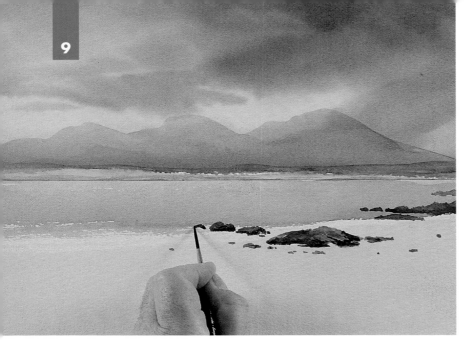

9 FOREGROUND Dry the beach. Using your rigger, mix Burnt umber with a little Cobalt blue. Paint in the rocks keeping their bottoms parallel to the horizon. Make some lighter, with more watery paint, and put dark patches at the rock bases.

10 Use White gouache on a clean rigger to paint waves in broken thin lines along the water's edge.

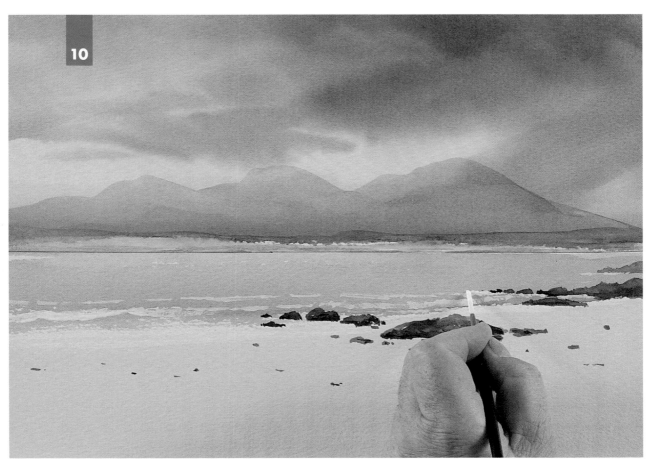

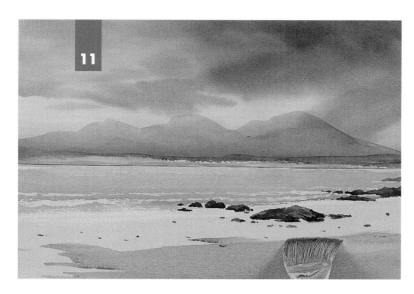

11 For the shadow the clouds make on the beach, mix up some watery Burnt umber with some Raw sienna. Use your large brush and paint one jagged swipe across the bottom of the paper.

12 Now add some birds (remember it's just a simple 'V'-shape) and sign your picture!

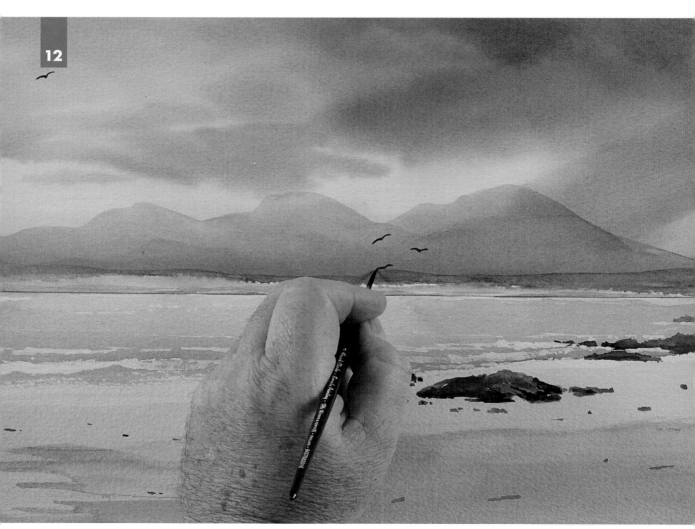

SEASCAPE

It's always helpful to constantly refer back to your subject as you paint it, whether it is a previously painted picture, a photograph, a still life or a real view.

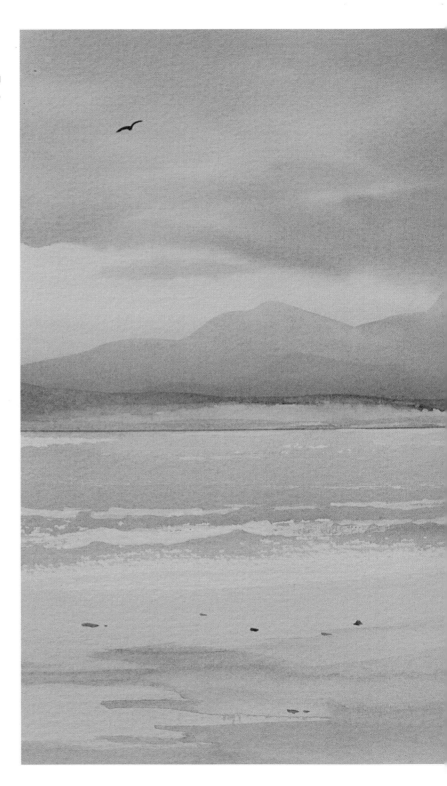

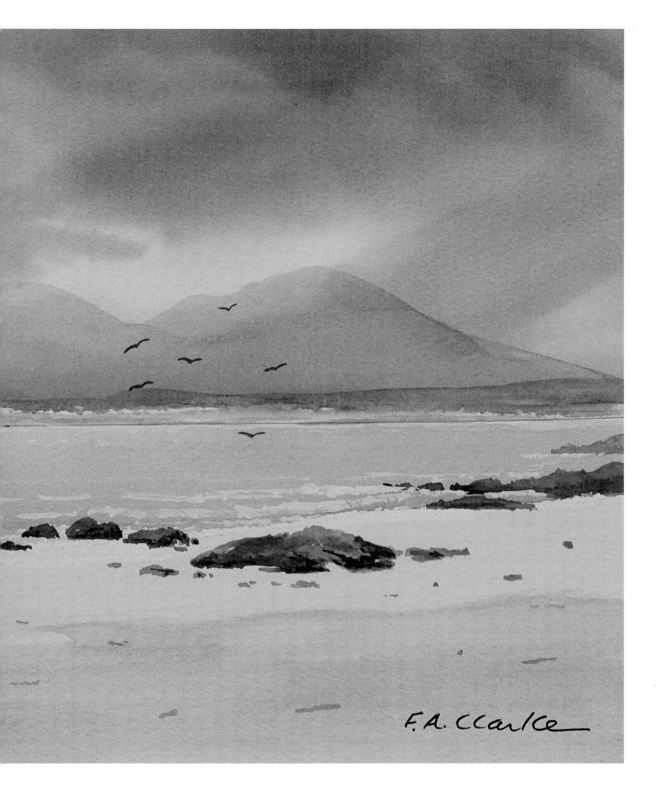

drawing and painting **boats**

Now you have completed your seascape, let's practise drawing or painting some boats ready to put them into your *next* seascape. There are several different methods you can use for constructing boats.

Drawing a rowboat

Here are two different ways to draw a rowboat. The first one below is very basic yet, once the boat is in the painting and you soften the bottom with White gouache waves, it works really well!

Draw a rectangle.

At each end draw a triangle and you have a simple boat. Why not add a half carrot to represent a man rowing the boat.

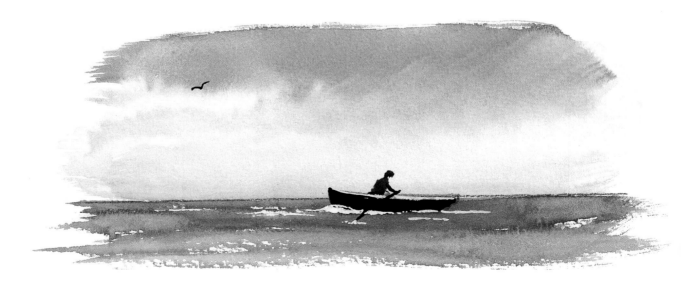

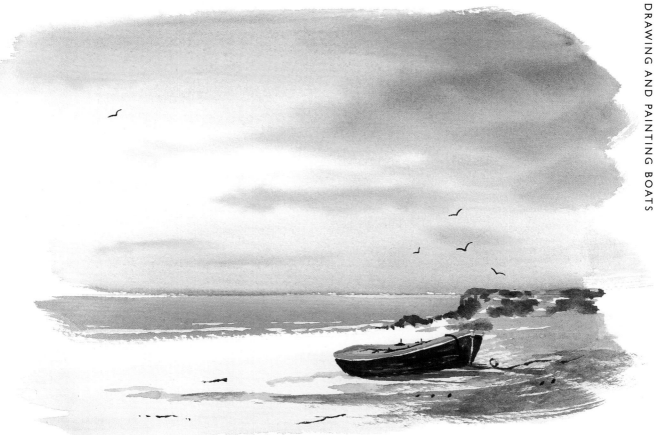

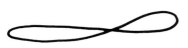

Draw a figure eight laid on its side and a little flattened.

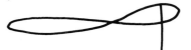

Now draw a vertical line down from the centre of the right-hand loop.

Next draw a curved line at the end of the left-hand loop.

Join the line ends and lastly join the right edge of the right loop to the bottom of the vertical line. Fill in some seats and planking to finish off.

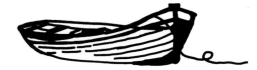

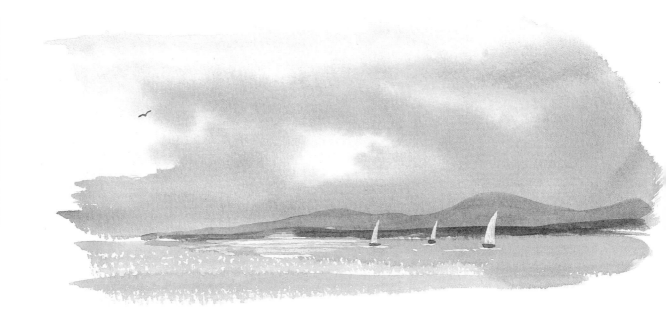

Painting a sailboat

To paint a sailboat, use your White gouache and rigger brush. When you have completed a seascape and once the paint is absolutely dry, paint in a triangle in the position you want your boat to be. This is the sail of a boat. If you want to paint several boats, make some of them bigger and some smaller and soon you will have a whole regatta.

When the gouache has dried, paint in the hull of your boat using a different colour of watercolour paint. If you want a reflection of the sail just paint a mirror image of the sail in with White gouache. Turn your picture upside down if you find it easier to do it that way!

Handy tip: The bigger boats should be lower down your paper. This gives the impression of the boat being nearer to you.

A rubbed-out sailboat!

There is another easy way of creating a sailboat once you have painted your seascape and it is dry. You'll need two pieces of card with straight edges for this trick!

Take the two pieces of card and place them onto your picture in the shape of a triangle (sail), where you want your sailboat to be.

Hold the cards firmly in place and, with a damp tissue, rub the area between them to gently lift off the paint on the paper. Remove the cards and wow! ... a sail.

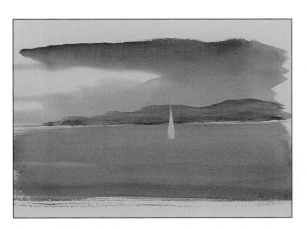

Now paint in a hull using your rigger brush and a little dark paint. Paint it as a single horizontal line under the sail. (Don't make it too thick or it will look too large for the sail.)

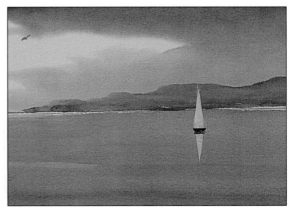

To make a reflection of the boat in the water, all you have to do is turn your seascape upside down and repeat the rubbing process. Make sure the reflection of the sail is the same size as the sail itself. Simple when you know how, isn't it?

winter wonderland

I love to paint snowscenes (see pages 54–55), because they are easy. They also save paint as you make use of the white of the paper for your snow. The best winter wonderlands are simple, so don't make yours too cluttered with detail.

you will need

- Paint: Raw sienna, Cobalt blue, Alizarin crimson, Burnt umber and White gouache
- Brushes: your large (1½-inch) brush, small (¾-inch) brush and no.3 rigger
- Paper: a sheet of 10 × 14-inch (255 × 355-mm) 140lb/300gsm watercolour paper
- Palette (your white plate or tray)
- Water pot
- Mop up cloths
- Pencil
- Ruler
- Eraser
- Board (16 × 20 inches (410 × 508 mms) to stick your paper on)
- Masking tape

1 HORIZON Using masking tape across the corners, fix your sheet of paper lengthways onto your board. Draw the horizon line about 3–4 inches (7.5–10 cms) up from the paper's bottom edge. Prop up the board.

Before you start your two-minute sky, have a good look at my examples to see what you will be painting. Squeeze out some Raw Sienna, Cobalt blue and Alizarin crimson.

2 SKY Using your large brush, mix the Raw sienna with water. Paint in broad strokes, from the top of the paper, down to within half an inch of the horizon line. Clean your brush. With Cobalt blue, while the paper is damp, paint in a corner of blue sky and a sausage across the centre.

3 Mix 40% blue with 40% Alizarin crimson and 20% Raw sienna. Paint in a stormy purple-grey side to the sky. Dry this.

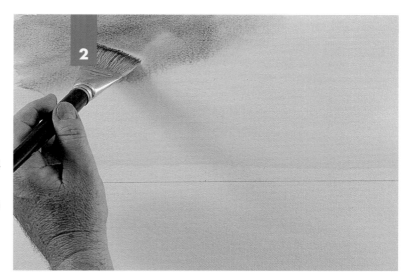

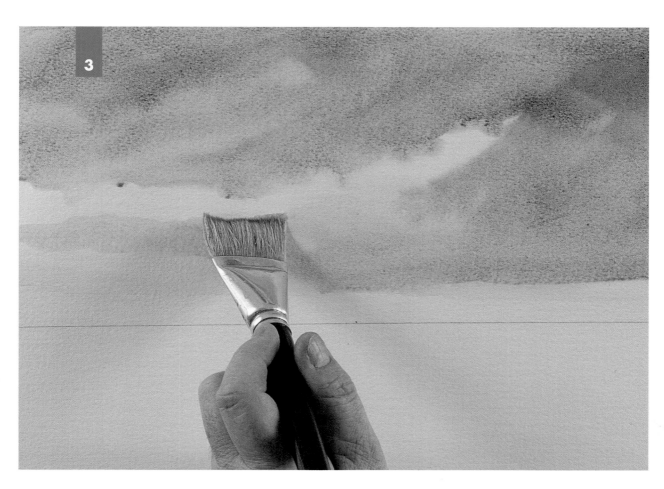

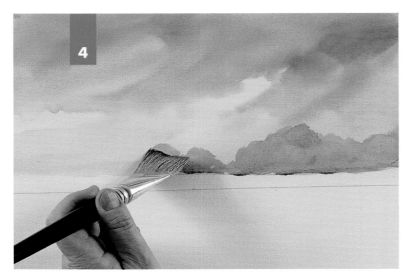

4 MIDDLEGROUND Staying half an inch above horizon line, and using the same mix of paint as you had for the purple-grey of the sky, paint in the distant trees using the corner of your large brush to create the ups and downs that will represent distant trees. Dry this.

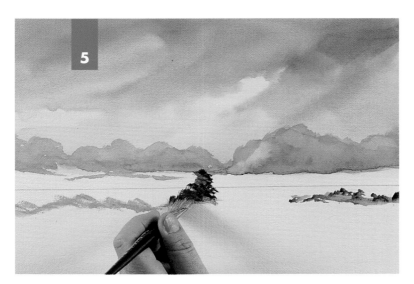

5 FOREGROUND Start with Raw sienna on a fairly dry, small brush. Keep the paint quite thick and heavy. Dab in some patches of hedge and bush. Build up a ditchline, going from light to darker paint, by gradually mixing in some Burnt umber with the Raw sienna.

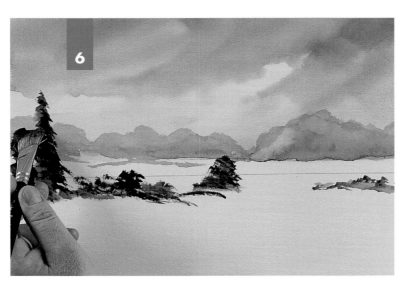

6 Use the corner of the dry small brush with a dark shade of paint to stipple in some trees to one side. Start at the bottom of each and dab up to a point. Don't fiddle – the bristles will create the spiked edges of the tree if your brush is dry enough.

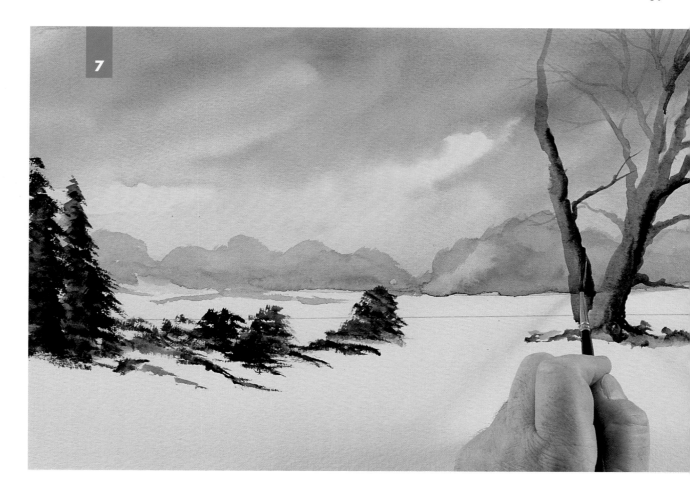

7 With the same mix of Burnt umber and Raw sienna, put in some dark areas trailing from the base of the hedgeline to show the grass poking through the snow.

Using your small brush with a mixture of Raw sienna, Burnt umber and a little Cobalt blue, paint in the tree trunk and main branches of the tree on the right. Start from the ground and work up. Next do the smaller branches with your rigger, by dragging the brush out and away from the main trunk. Lift the brush off the paper as you go to form the spindley ends to the branches. Don't go mad – just a few branches will do! For the second tree, repeat this exercise. Now, add a little more Burnt umber and Cobalt blue to make a darker shade of paint. Use this to put in some shadow patches along the right sides of the trees.

8 FOREGROUND For the road, use your rigger and Raw sienna. Paint wobbly lines: one from the base of the trees out to the corner of the picture, the other directly down your page. Add detail where the snow is melting. Mix a touch of Cobalt blue with Burnt umber for the leaning fenceposts. Join with a hanging (*not* straight!) wire.
9 With Raw sienna on an almost dry small brush, put in the grass. Dab Burnt umber over this. Add a little Cobalt blue to the brush to darken the base of the big trees.

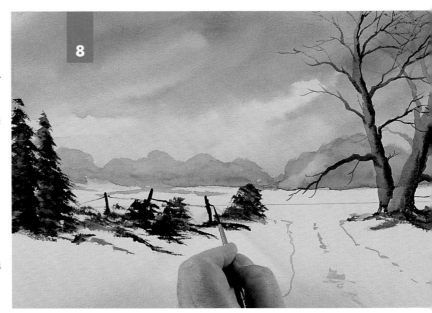

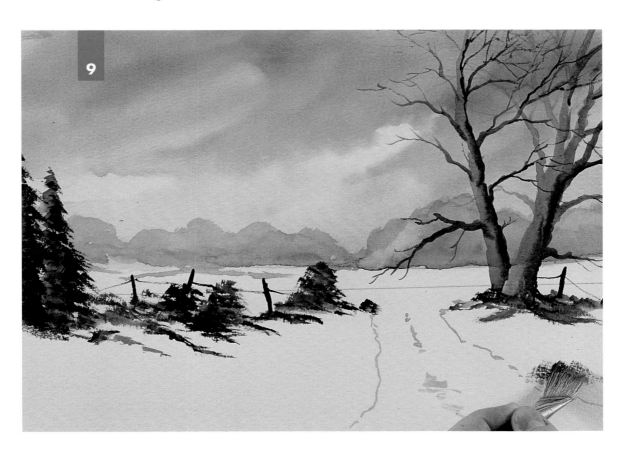

10 Now, using your rigger with Burnt umber, paint in a few wisps of grass poking through the snow. Go from the bottom of the blade, up, lifting the brush off the page as you go to get a thin point at the tip of the blade.

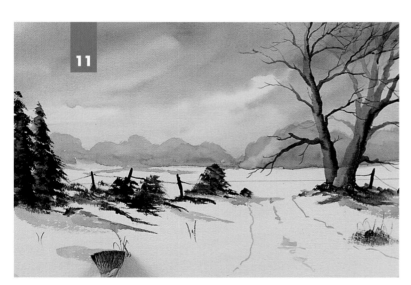

11 The shadows in winter scenes are really important as they allow us to create the undulations in the ground. For these, mix up 40% Cobalt blue, 40% Alizarin crimson and 20% Raw sienna to get the same stormy purple-grey colour you used in the sky. Use your small brush and put in the shadows, remembering that the light is coming from the left side of the picture (where sky is bluer).

12 With your rigger and some White gouache put snow on the topsides of tree branches and the tops of the bushes. Paint carefully and don't overdo it!

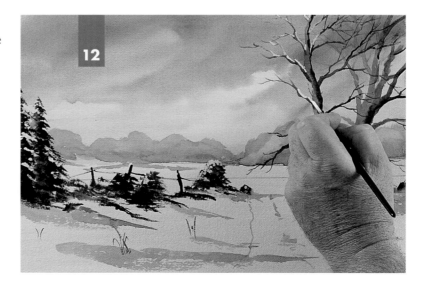

WINTER WONDERLAND

Put in a bird. Let everything dry
completely and then gently rub
out your horizon line. For most
paintings you don't have to
bother rubbing the line out, but
as there is no paint to cover it
on this particular picture, it's
much better to get rid of it. Sign
your picture and there you go
… another masterpiece.

Handy tip: When you have
painted your winter scene, it is
possible to have greeting cards
printed from your painting. If
you find a good local printer, it
can be quite inexpensive. And
won't your friends be surprised?

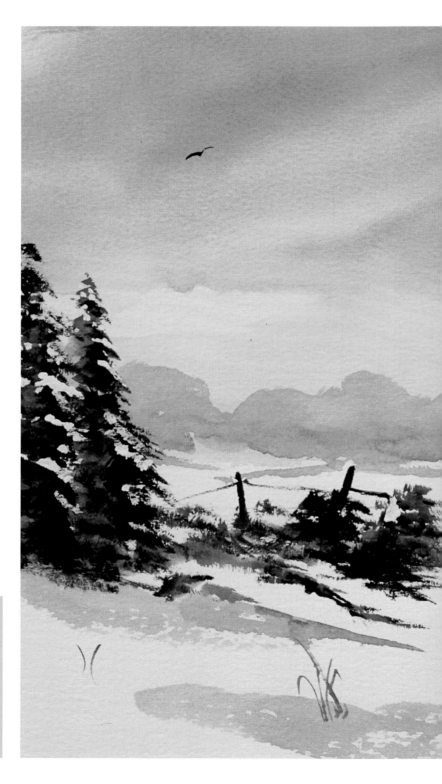

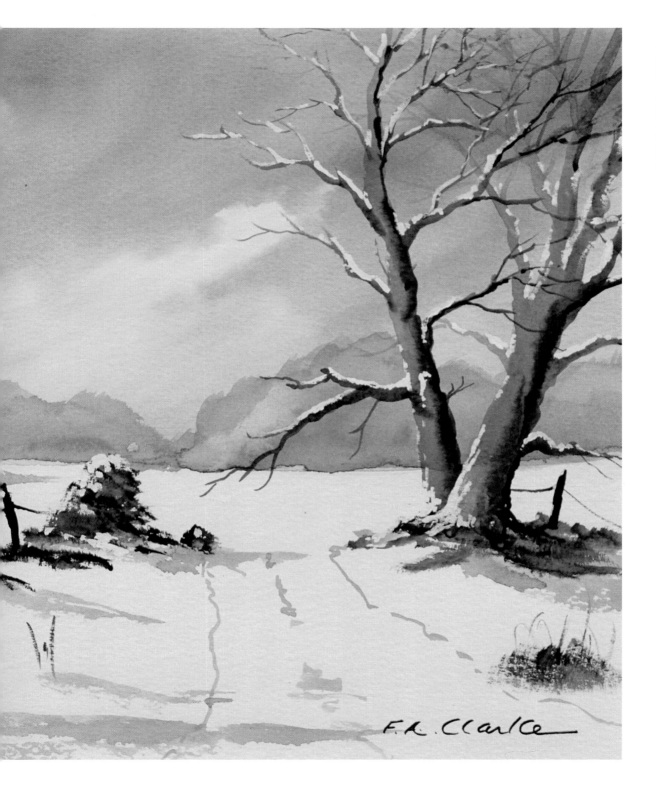

F.R.Clarke

greeting *cards*

With the knowledge you now have of how to create snowscenes, why not try some of these simple winter landscapes or a robin to make some greeting cards? Here are some simple ideas to get you started.

Draw a large egg shape and a small one, then position a tail. beak and legs.

Using a rigger, paint from head to tail to form a wing and then add the colour detail.

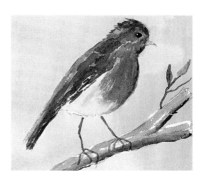

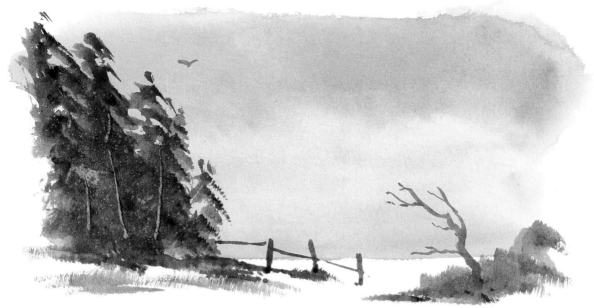

F.A.Clarke

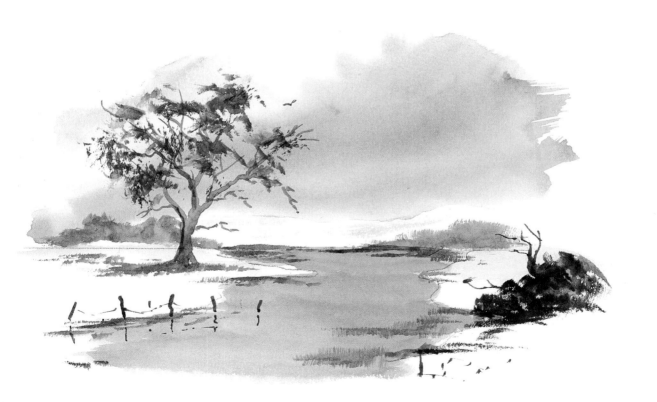

still life flowers

Even though this is a still life (see page 67) we can use the Have Some More Fun painting technique. With creative licence it can be applied to absolutely anything you paint, as you will see. Use an old brush for the masking fluid if you have one.

you will need

- Paint: Cobalt blue, Alizarin crimson, Lemon yellow, Raw sienna, Light red and Burnt umber
- Brushes: your large (1½-inch) brush and no.3 rigger (also an old small brush to use with the masking fluid if you have one)
- Paper: a sheet of 10 x 14-inch (255 x 355-mm) 140lb/300gsm watercolour paper
- Palette (your white plate or tray)
- Water pot
- Mop up cloths
- Pencil
- Ruler
- Eraser
- Board (16 x 20 inches (410 x 508 mms) to stick your paper on)
- Masking tape
- Masking fluid

When painting with masking fluid, always start at the top of your picture and work down. That way you won't get your sleeve in it! Masking fluid can damage your brush. To avoid this happening, dip your brush in water first before you dip it into the fluid. When painting with masking fluid I clean the brush every 20 seconds. This stops the fluid from drying on the brush. Keep painting until you have finished all the masking fluid areas then immediately put your brush into water and screw the top on the fluid. If you let the brush dry out it will become clogged with rubbery lumps. If this happens you can use white spirit to clean your brush, but it can damage the bristles so don't make a habit of using it.

To paint flowers it is necessary to sketch them first. Don't worry, it's easy, just simplify. So before we start painting our still life, let's practice drawing some daisies and a flower pot.

These daisies are a central circle with two curved lines for each petal. From the side view the centre is a flattened circle. You can see the stem, too, but this is also just a few simple curved lines, and a zigzag one.

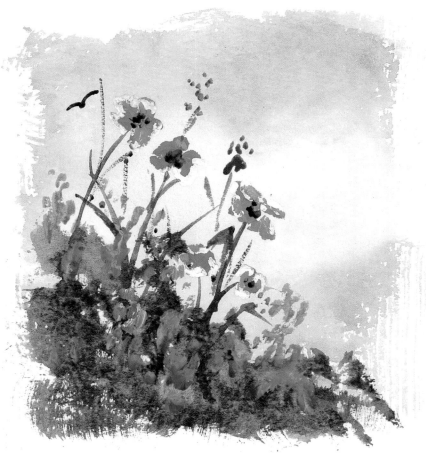

Flower pots are not complicated either. First draw a rectangle for the rimmed top. Put in two lines for the sides and join them with a slightly curved line at the bottom. The main thing to remember with pots or vases is not to make them too large.

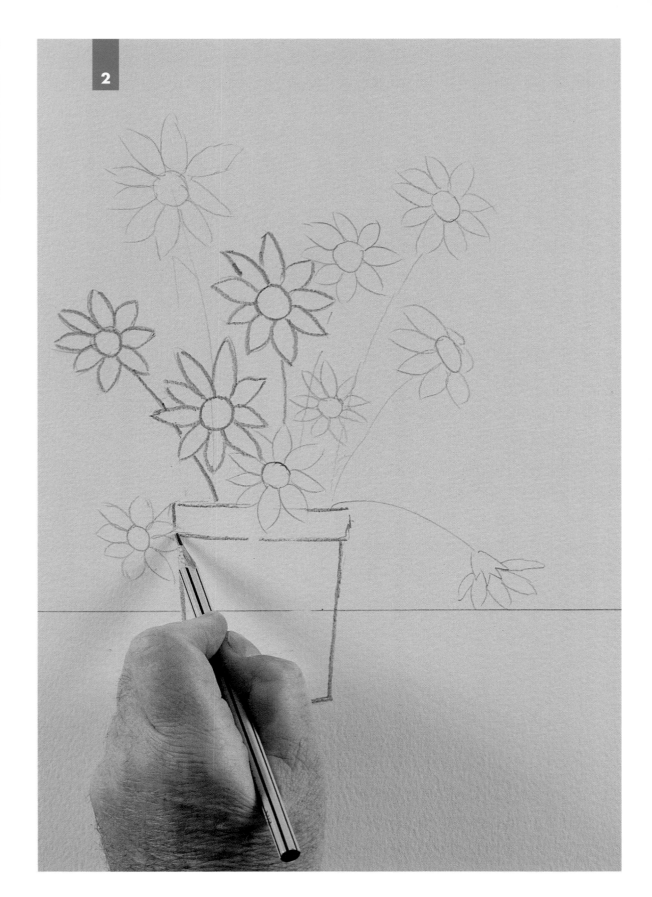

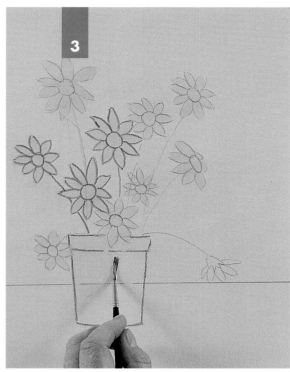

1 HORIZON Using masking tape across the corners, fix your sheet of paper upright (portrait) onto your board. With a pencil, draw the horizon line about one-third of the way up from the paper's bottom edge. Prop up the board.

2 Before starting, have a good look at my example (*see left*) to see where the pot sits in relation to the horizon line and where the flowers are positioned. Begin by sketching in your pot with a pencil. Don't make it too large. Now put dots on the paper where the centres of the flowers will go. (This helps you to compose your picture and get the positioning right – take your time, rub out and start again if need be.) When you are happy with the overall positioning, draw the centre circles of your flowers in and sketch the petal outlines. Create different flowers, some drooping and seen from the side and some facing you. Now draw their stalks and pencil all lines in harder if you need to.

3 Dip your old brush (or rigger) into water and load it with masking fluid. (Don't forget the 20-second rule and clean your brush regularly.) Start at the top of the page and fill in the pencil outlines of the flowers, stems and pot. Immediately you have finished, put the top on the fluid and wash your brush. Dry your painting.

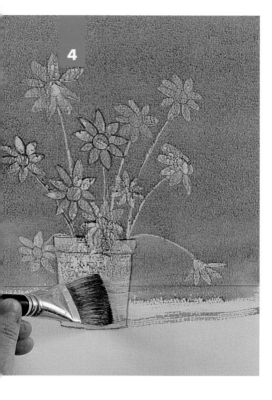

4 SKY Check the masking fluid is *completely* dry before you continue or you will ruin your picture. Using your large brush, mix Cobalt blue with some Alizarin crimson. From the top of the page, using broad strokes from one side to the other, paint to the bottom. (There's no need to wet the paper first but you must paint quickly to avoid a streaky finish.) Dry this.

5 MIDDLEGROUND With the same colour, paint the area under your horizon line. (This darker shade of purple represents the tabletop.) Dry this but do *not*

remove the masking fluid yet.

6 Clean your large brush and mix up Lemon yellow with some Raw sienna. (Look hard and consider where the foliage lies in relation to the flowers and stalks, and where the light makes the leaves lighter.) You want a mottled effect, so use varying mixes of your two colours and work from a light to a darker shade. With an almost dry brush, use the corner to stipple in a light patch of paint on the right side of your foliage area – above the top of the pot and in among the stalks. Now mix some Cobalt blue into your Lemon

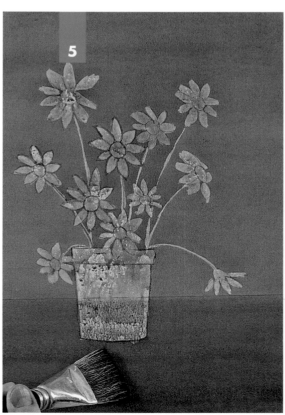

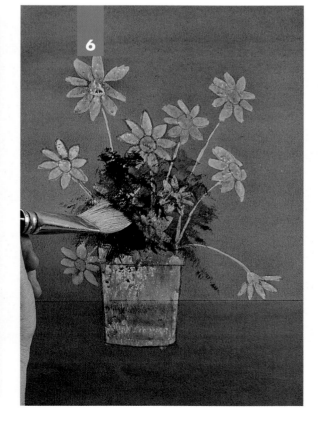

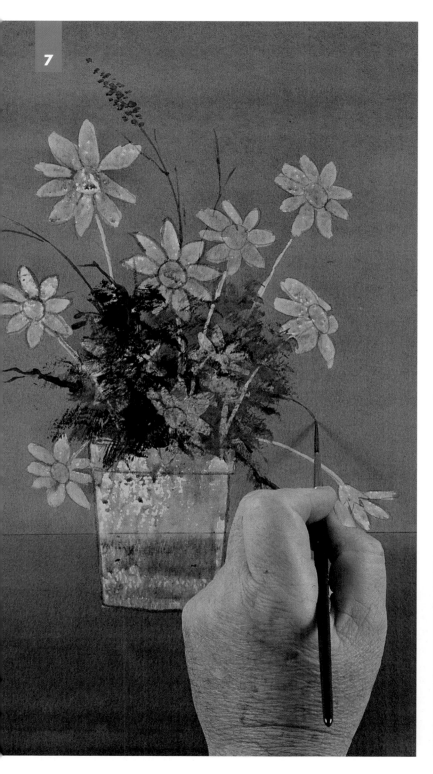

yellow and Raw sienna mixture to get a dark green and again, using the corner of a dry brush, stipple in more foliage on the left side (away from the sunlight) of the leaf area.

7 Still using the same mix of dark green paint, use your rigger to draw in some delicate wispy stalks of grasses. These start in among the foliage. Use the tip of the brush and, with a light free-flowing motion, sweep it away from the leaves, lifting the brush as you do so to get a thin tip to each grass. Don't go wild and overdo these. You can put some detail onto the end of one or two of these by dotting gently with the tip of the brush to form a few grass seeds. Now dry the whole picture.

Handy tip: Whenever you paint, whether you are copying from a picture or using a real still life arrangement or landscape, keep looking at what you are painting. Before you even start it helps to take a little time to have a really good look at your subject.

64

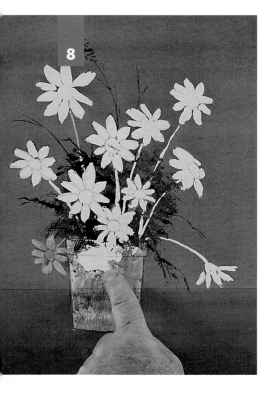

8 MIDDLEGROUND Check the paint on the masking fluid is completely dry. Use your finger or eraser and remove the masking fluid. Work from the edges of your pot or petals inwards. Lift off the rubbery lumps. Don't worry if there are a few bits of paint on the white underneath, nature is not perfect and you won't notice them on the finished painting. Whatever you do, don't fiddle and try to remove them.

9 FOREGROUND Start from the top of the picture and, using your rigger and small delicate strokes with the tip, paint the centres of the flowers with a mixture of Light red and Raw sienna. Leave a touch of white paper to represent the areas where the light is hitting them.

10 Most of the flowers are white but use some Lemon yellow with the odd touch of Alizarin crimson here and there and paint the petals of three flowers, again leaving bits of white for effect. For the stalks, mix Lemon yellow with a little Cobalt blue and paint this onto the previously masked areas running into the pot with the rigger.

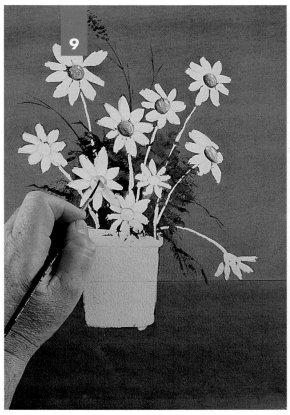

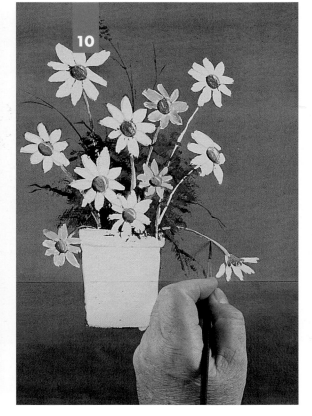

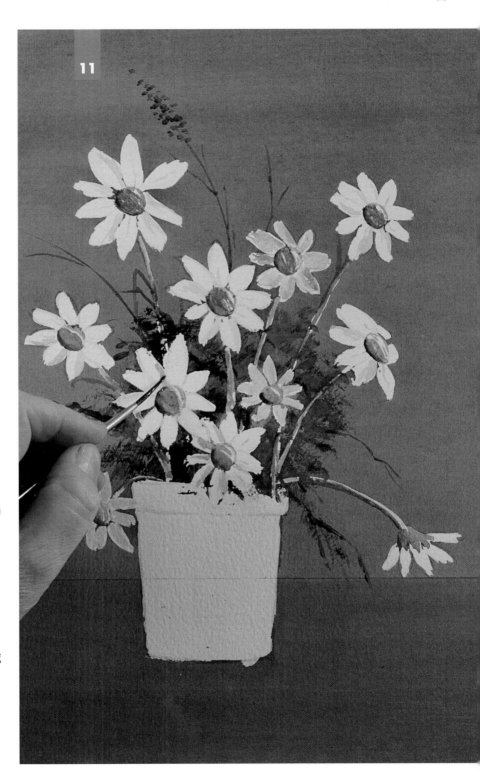

11 Take a moment to look again at your subject (my finished picture on page 67) and note that the light is coming from the top right corner of the picture. Try to imagine which petals would logically be in the shade – it would be those which are lying just under another petal. With your rigger mix up some watery, pale Cobalt blue with a tiny bit of Light red and apply shading sparingly.

12 FOREGROUND For the pot, start on its right side (we're painting from light to dark remember). With a weak mixture of Raw sienna on your rigger, paint downward strokes, leaving tiny gaps of white in each stroke at the same point on the pot to indicate its rim. Try to imagine the curved shape of the surface – to get this curve the trick is to keep changing the colour and get darker as you go round to the left. As you go across the colour changes. First use Raw sienna, then a mixture of Raw sienna and Burnt umber, then add in some Cobalt blue for the left, dark side of the pot. Enhance under the rim with a broken line of darker paint.

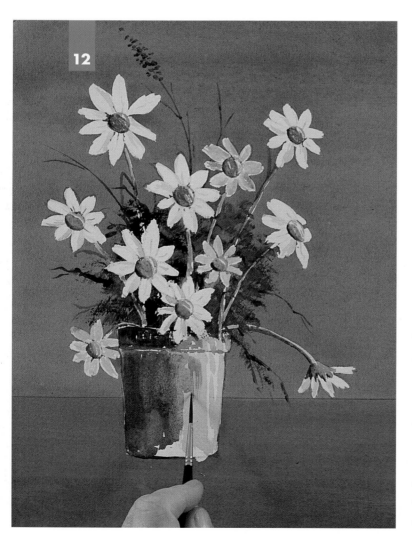

STILL LIFE FLOWERS

To finish off you can add a few fallen leaves on the table top, to break it up a little (a mix of Lemon yellow, Cobalt blue and Raw sienna). As the light comes from the right, the shadow of the arrangement will fall away to the left of the base of the pot. It's made with a mixture of Light red and Cobalt blue, using your rigger brush. Don't make it too big. I've put a bird in but you don't have to if you don't want to. Now sign your painting and there you go!

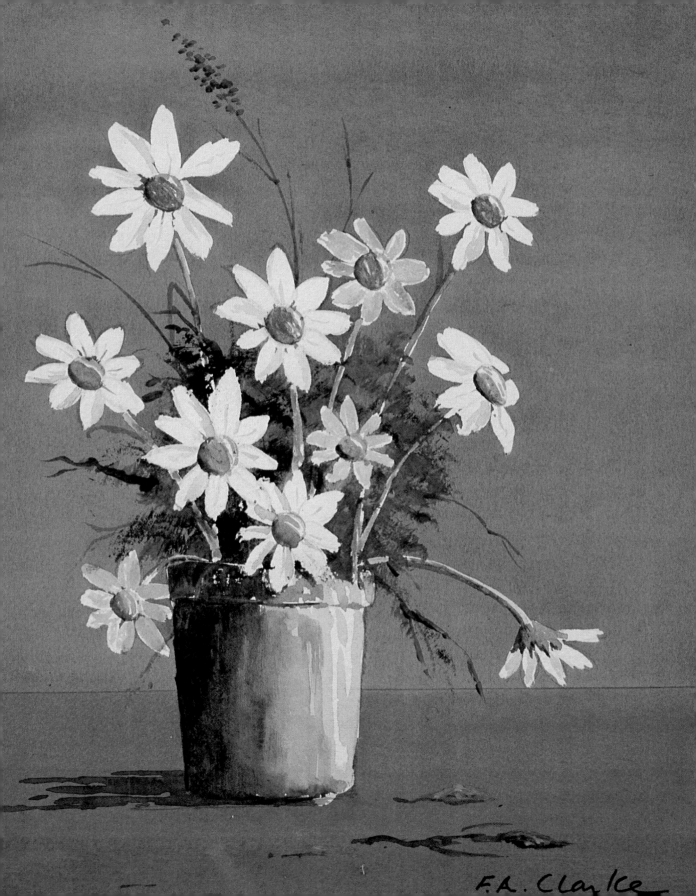

F.A.Clarke

misty hills

Misty hills (see pages 74–75) are a popular and requested theme in my painting classes. With mist, the sky is painted in a slightly different order, putting in the light sky, then the hills, then back to the sky for the mist. It's easy ... let me show you.

you will need

- Paint: Raw sienna, Cobalt blue, Payne's grey, Burnt umber, Lemon yellow and White gouache
- Brushes: your large (1½-inch) brush, and no.3 rigger
- Paper: a sheet of 10 × 14-inch (255 × 355-mm) 140lb/300gsm watercolour paper
- Palette (your white plate or tray)
- Water pot
- Mop up cloths
- Pencil
- Ruler
- Eraser
- Board (16 × 20 inches (410 × 508 mms) to stick your paper on)
- Masking tape

1 HORIZON Using masking tape across the corners, fix your sheet of paper lengthways onto your board. Draw the horizon line about a quarter of the way up from the paper's bottom edge. Prop up the board.

Handy tip: Test your mixed paint colour on a piece of scrap paper to make sure it's the required shade before you put it on to your picture.

2 SKY Using your large brush, make a weak mixture of Raw sienna and with broad strokes from the top, paint down to within half an inch of the horizon line. Dry this.

3 MIDDLEGROUND With the large brush mix up Cobalt blue with a little Payne's grey. Draw a large, wobbly 'M' from one side of the paper to the other to represent the hills.

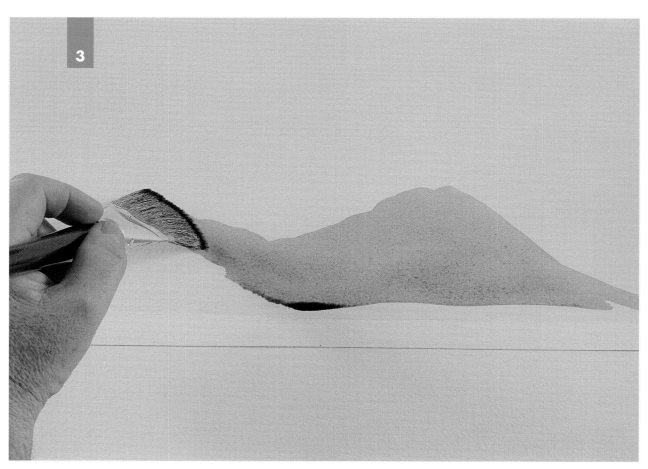

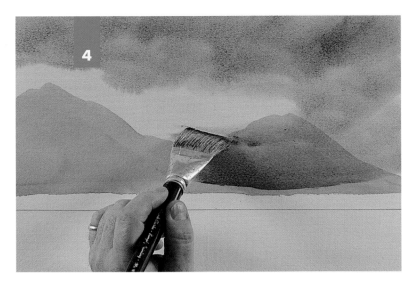

4 & 5 SKY For the mist use the Cobalt blue/Payne's grey mix you had for the hills. The two-minute rule now applies so with a clean large brush and water *only,* wet the paper from the top, going down over the sky *and* hill area. While still wet, apply the mist with horizontal strokes of the brush. Go over your hills but leave patches of light shining through the sky above. Dry this.

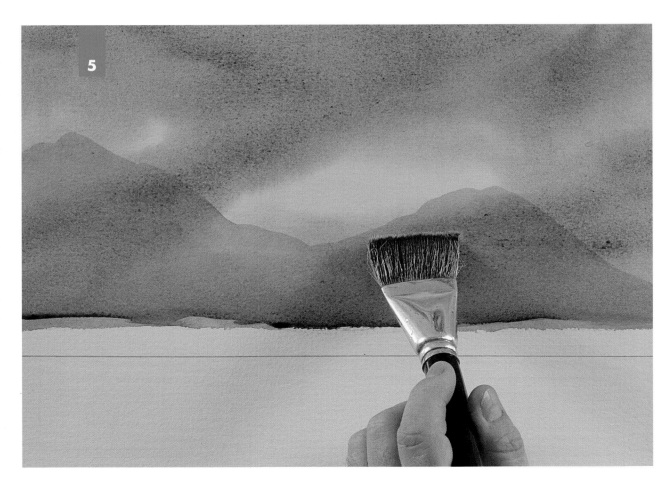

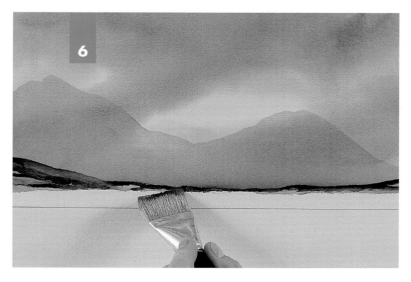

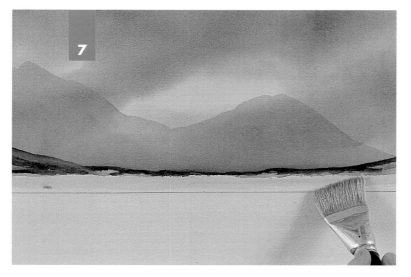

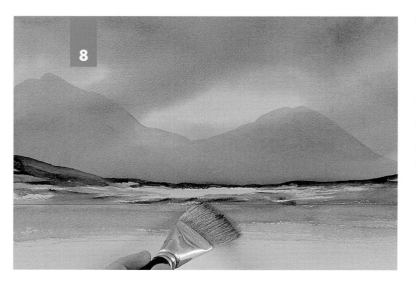

6 MIDDLEGROUND With the large brush, mix up some Burnt umber with a little Lemon yellow. We want a good dark colour for the boggy ground at the base of the hills. Keeping the brush quite dry and using the corner and tips only, dab across the base of the hills. Keep above the horizon line and leave tiny flecks of white and some of the blue of the hills, here and there, for definition and to shape the land. Dry this.

7 With a cleaned brush, mix some Lemon yellow with a little Raw sienna and sweep this across to fill in the area still empty above the horizon line.

8 FOREGROUND Squeeze out some Lemon yellow, Cobalt blue and Raw sienna. You are going to use these three paints, neat and in varying mixes to get different shades and colours, to create a mottled foreground. Keep looking at my example (*also see overleaf*) and gradually build up the grassland. With the brush almost dry, dab Lemon yellow mixed with Cobalt blue to get greener patches; dab Raw sienna mixed into this for more earthy tones. Experiment on a scrap of paper if you are worried.

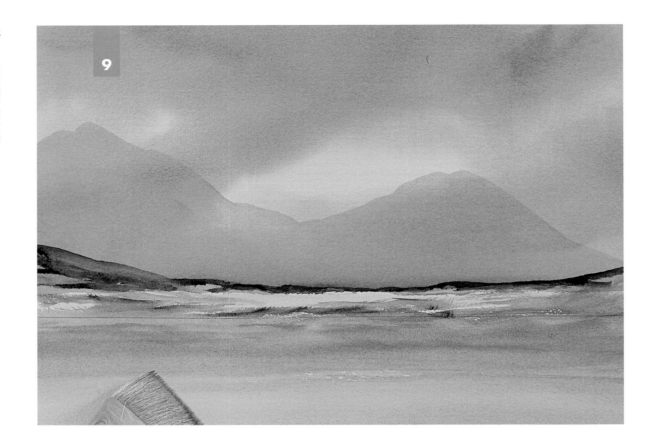

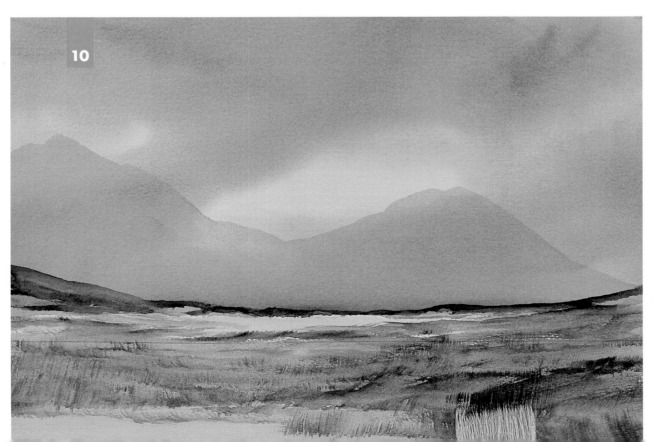

9 FOREGROUND Don't overwork the area under the hill. The bottom of the foreground is made with larger sweeps of paler colour. Dry this.

10 With Burnt umber on the tips of your almost dry, large brush, make short downward strokes to create some reeds and rushes. Dot these about but don't be too heavy-handed. Towards the bottom of the page the strokes should become slightly longer as the reeds get bigger the closer they are to you.

11 For the bog cotton, use some White gouache on the tip of your rigger. Paint dots of it here and there. Remember, the bog cotton nearest the bottom of the page will be marginally bigger than that further up because it is closer to you. Don't go mad and don't cover the entire foreground as you will spoil your picture. Sometimes, less is better than more!

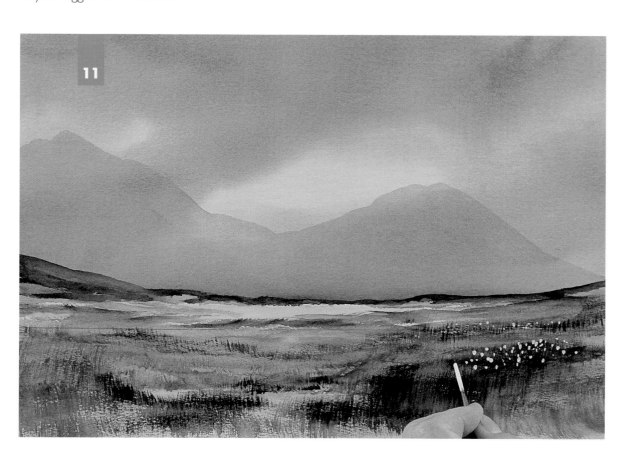

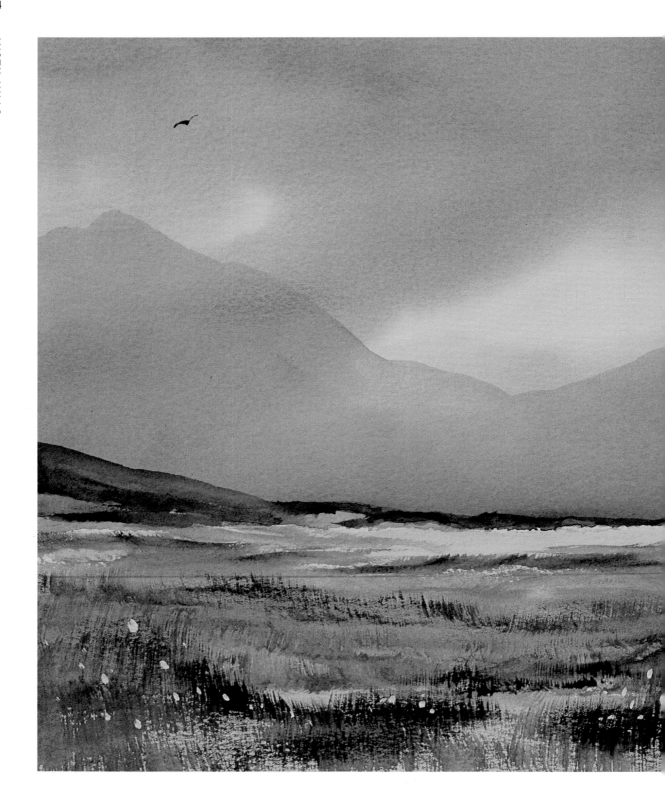

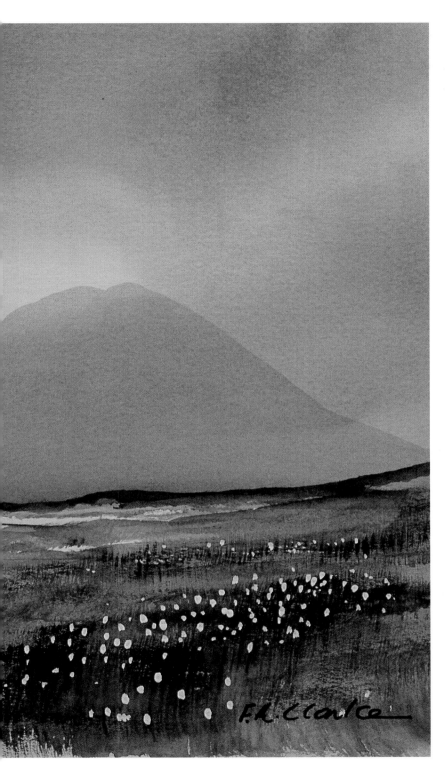

MISTY HILLS

Now a bird and a signature and you have a misty hill scene ready for hanging on your wall.

drawing and painting **sheep**

As you can now paint a misty hill scene, you might like to put some animation into it, or the next scene you paint like this. So how about practising some sheep? Just like painting people, let's simplify a sheep using circles.

Start by drawing a freehand circle.

Now draw a small squat carrot on top of this, leaving out its pointed tip. Put ears on.

Lastly, put legs on it – just two, as you can't see the back legs. And there you have your sheep.

To draw a grazing sheep, make a loop and place the sheep's head at the bottom. No legs required!

Draw a flock of sheep and make them get slightly smaller as they go further away from you.

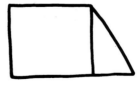

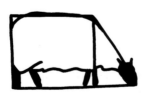

For the side view of a sheep, draw a broad rectangle.

At one end, put on a triangle to represent its shoulders and neck.

Draw in a belly, head (with ears) and four legs at varying angles coming to the ground at the same level as the sheep's nose.

To put sheep into a landscape painting you need to paint the picture first and then when it's finished, and dry, lightly draw the sheep in position onto your picture using a pencil. With White gouache and your rigger brush, paint in the sheep's bodies. Once the bodies are dry, paint the heads and legs. When the sheep are completely dry gently rub out the pencil marks if you want to. It won't damage your picture if you don't rub too hard.

Handy tip: Don't be too heavy handed when drawing your sheep into a picture. Remember to scale them down as necessary to fit them sensibly into their surroundings. (You don't want huge sheep looking like something from outer space!)

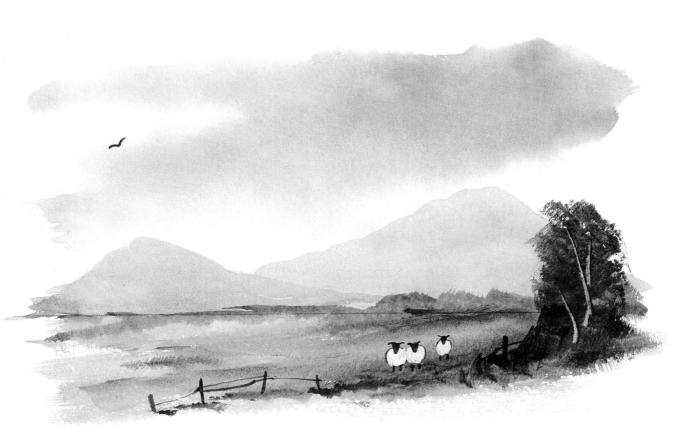

woodland scene

Woodland scenes (see pages 84–85) give us an opportunity to paint trees, which are always great fun. The trick is to not make them too complicated or fussy. So, with this in mind, let's go down to the woods … as they say!

you will need

- Paint: Raw sienna, Ultramarine blue, Lemon yellow, Burnt umber and White gouache
- Brushes: your large (1½-inch) brush, small (¾-inch) brush and no.3 rigger
- Paper: a sheet of 10 x 14-inch (255 x 355-mm) 140lb/300gsm watercolour paper
- Palette (your white plate or tray)
- Water pot
- Mop up cloths
- Pencil
- Ruler
- Eraser
- Board (16 x 20 inches (410 x 508 mms) to stick your paper on)
- Masking tape

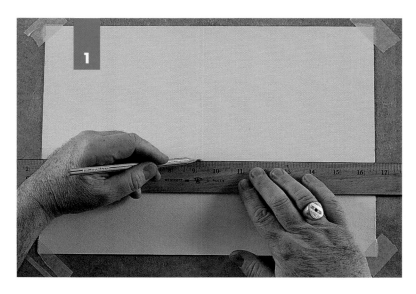

1 HORIZON Using masking tape across the corners, fix your sheet of paper lengthways onto your board. Draw the horizon line just under halfway up the paper. Prop up the board.

Squeeze out some Raw sienna and Ultramarine blue.

2 SKY Using your large brush, mix the Raw sienna with water. Remember, you've got two minutes, so paint from the top of the paper down to the horizon line. Clean your brush. Quickly mix Ultramarine blue with water and paint the blue over the whole area of still damp Raw sienna. (It's a sunny day and there are no cloud gaps.) Dry this.

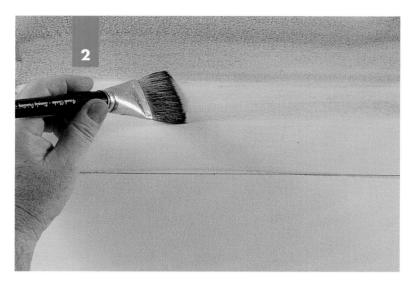

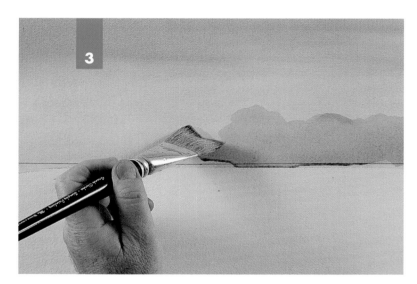

3 MIDDLEGROUND Make up a light watery mix of Raw sienna and Ultramarine blue. Use this to draw in the bushes with your large brush. They are in the distance so they need to be quite pale and feint. Start above the horizon line and fill in the whole area down to the line.

4 For the horizon line foliage, use a darker mix of 20% Ultramarine blue and 80% Raw sienna. Dab, with the horizontal tips of your large brush, to get a thin, slightly undulating edge. Use your small brush with pale Raw sienna and paint in a ½-inch strip below the horizon line. Dry this.

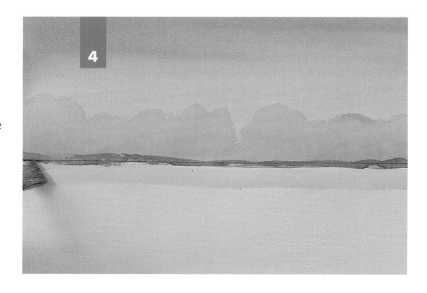

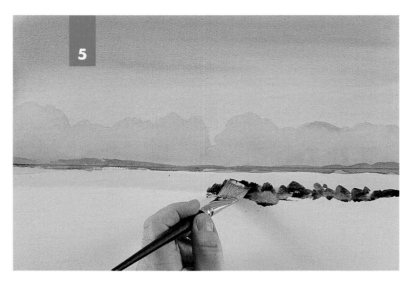

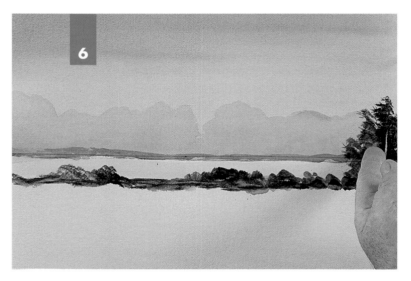

5 MIDDLEGROUND Still using the small brush, mix together some Lemon yellow, Burnt umber and Ultramarine blue. Dab in the hedge using the corner of the brush to create the ups and downs. Alter the colour by picking up more yellow or more umber to give different shades of foliage. Don't be too fussy, but a little variety in tone and colour enhances your picture. Dry this.

6 Clean your brush and make up some green by mixing Lemon yellow with Ultramarine blue. Keep the paint quite thick and the brush fairly dry. Dab with the corner of the small brush from the bottom of the bush, up. The dry bristles will give a leafy effect. While the paint is still wet use a fingernail to scratch in a trunk and a few branches. Don't do too many.

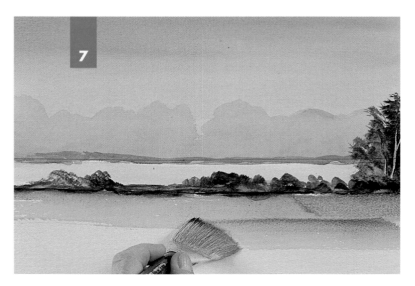

7 FOREGROUND With the large brush wet, mix some Raw sienna with Lemon Yellow and Ultramarine blue for the grass. Sweep the loaded brush across the foreground in two or three broad strokes (just like you painted the sea or lake in other pictures). Dry this.

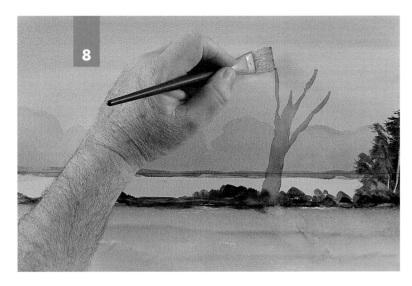

8 Use a corner of the small brush and a watery mix of equal parts Raw sienna and Burnt umber with a bit of Ultramarine blue to paint the trunk and main branches of the distant tree.

9 Use your rigger to add the thinner branches by dragging out and away from the main branches. Lift as you drag to get spindley branches. For the second darker tree, repeat this action with a less watery mix of the three paints.

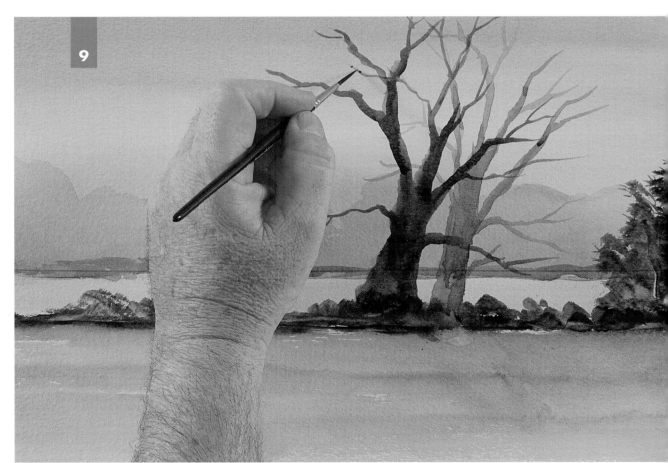

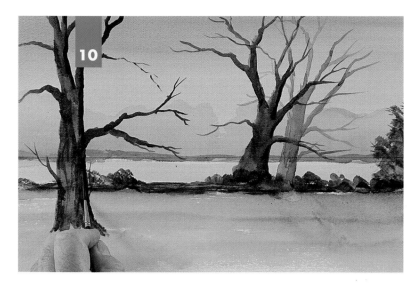

10 FOREGROUND The last tree is closer and even darker. Still using the Raw sienna, Burnt umber and Ultramarine blue mix make up a very dark shade. As before, paint the tree. The light is coming from behind the trees to the left, so, use your rigger with Burnt umber mixed with a little blue and shade down the right sides of the trees.

11 The sun will also throw the shadows made by the trees onto the grass. Make a mix of Lemon yellow, Ultramarine blue and Raw sienna. Now, holding the large brush horizontally like a chisel, make downward brush strokes to create a shadow.

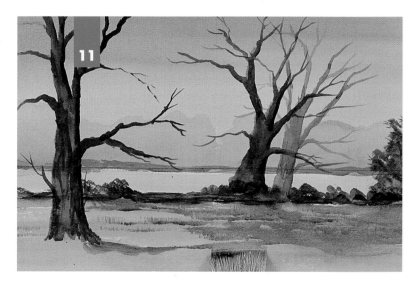

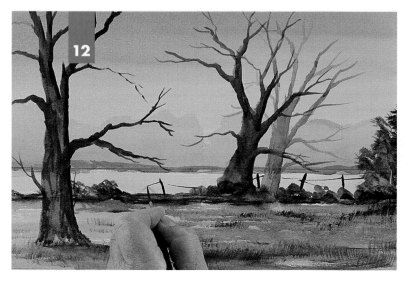

12 With the large brush almost dry, add patches of pure Burnt umber with short strokes to give blades of grass (like the reeds we've done before). Mix up a runny but dark Burnt umber with your rigger and paint the leaning fenceposts. Don't run the fence right across the page as this will visually cut the picture in half.

13 With the tip of your rigger, dab in Lemon yellow and White gouache wildflowers.

14 Mix yellow, Raw sienna and a bit of Ultramarine blue to get a pale green. With an almost dry, large brush dab with the corner to form leaves on the far right tree. For the middle tree use the same three colours to mix a darker green, and dab this in. Paint the left tree first with the lighter, then the darker green.

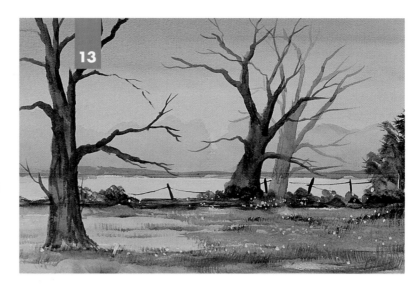

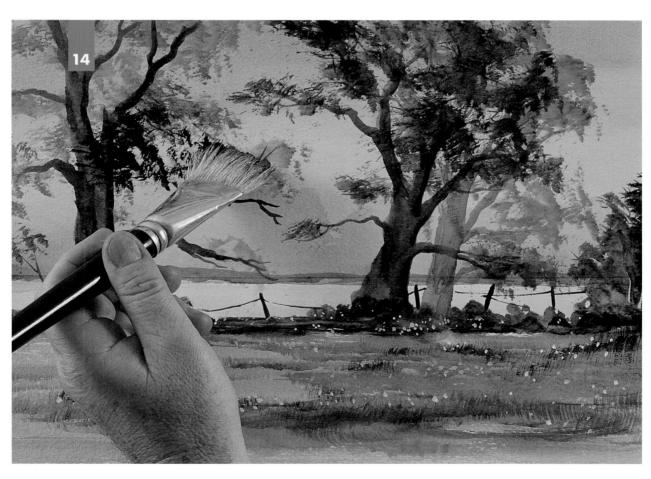

WOODLAND SCENE

Don't fiddle or you will
overwork patches of the paper
and ruin your painting. Finish off
by signing your masterpiece
with a pen.

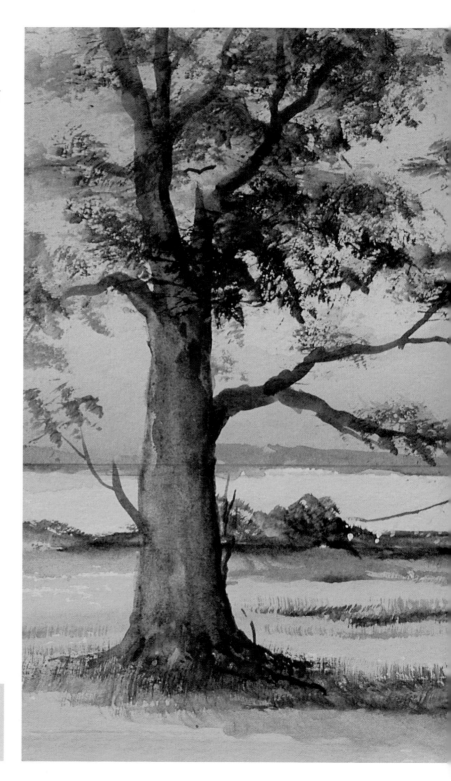

Handy tip: Don't sign your
picture too near the edge or
your frame will cover it.

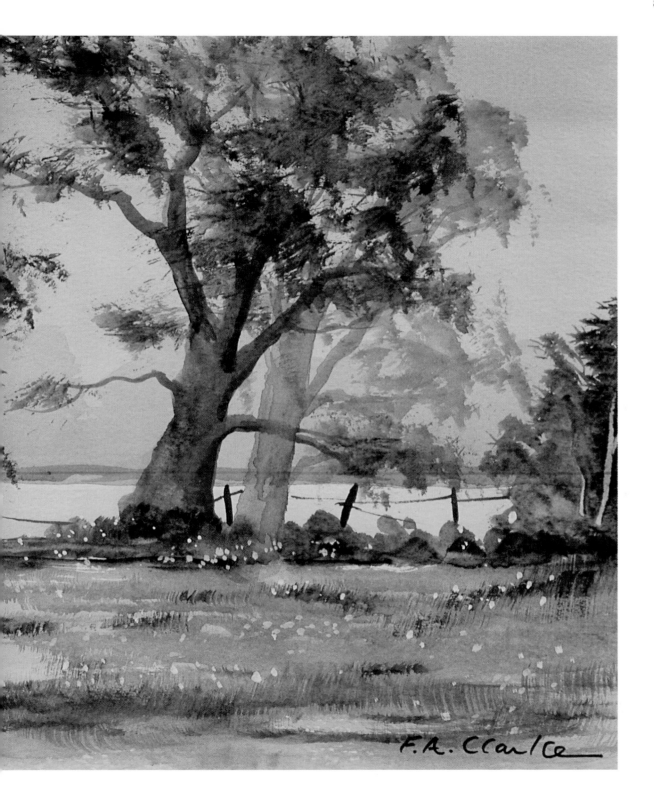

F. A. Clarke

drawing and painting **COWS**

Now you can paint a field, let's put some life into it. Remember this is practising here, and you should add cows to the next country scene you paint. Don't touch the masterpiece you've just finished. When you draw a square, always check it. Our eyes tend to deceive us and when you look hard you might be surprised to find that your square is probably not tall enough. Alter it before you start sketching in your cow.

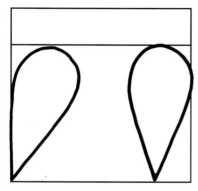

Draw a square freehand with a horizon line a quarter of the way down. Put in two carrots, the right one is upright and the left is tilted, touching the edge of the square all the way down.

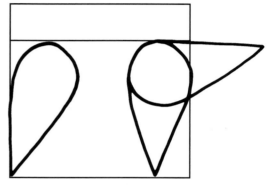

Now draw a third carrot the same size as the other two but pointing straight out of the box, at right angles to the front legs.

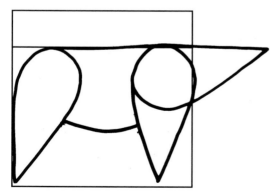

Join the two legs to form the straight back and slightly curved underbelly of your cow.

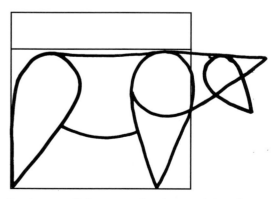

Put in a small, fat carrot for the cow's head.

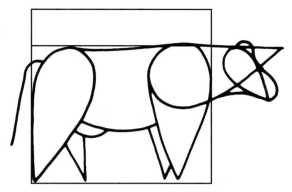

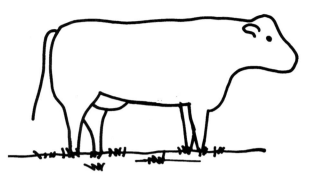

Round off the face and draw in the other two legs on the far side (they're just the bottom tips of carrots). Draw a curve to form the cow's udder and position a tail.

Now shape the legs a little and add a rounded ear, and an eye. Finally, a few blades of grass will help to 'ground' your cow.

Handy tip: Animals will become easier if you repeat the drawing exercises a couple of times before putting them into a painting. Get a photo or picture from a magazine and try out the carrot method when copying them. Practise painting them, too, to try out different colourings and markings, and always 'ground' your beasts with a few blades of grass so they don't float above the field.

drawing and painting **horses**

The front or rear view of a horse is a carrot, with a head (a squat carrot with ears) or a tail, and a rider – the top half of another carrot with his head and collar. The side view (see opposite) uses the same square and carrot idea as the cow.

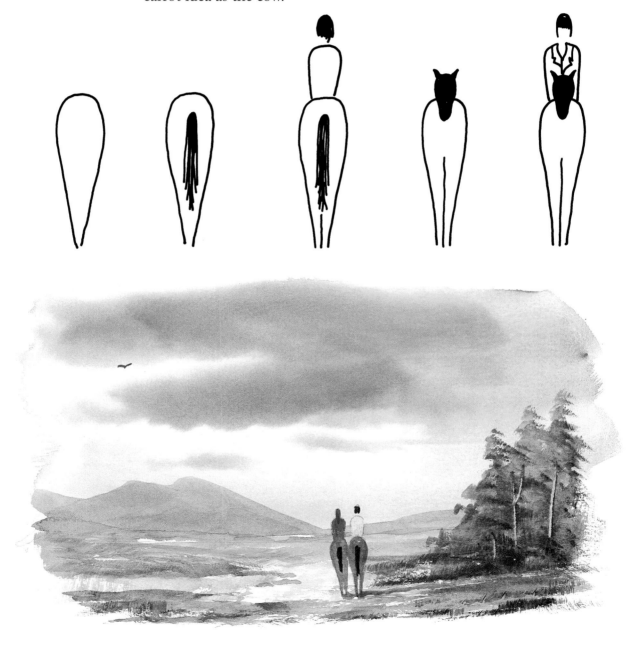

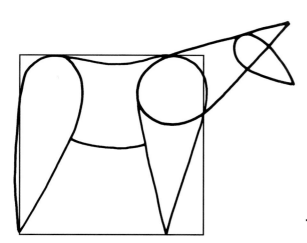

Draw your square and two tall carrots. Add a third carrot pointing skyward. Join the legs to form a dipped back and belly. Put in a small carrot head.

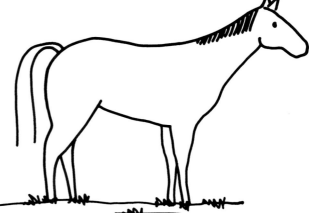

Narrow the front leg and round off the rump. Add the other two legs. Round off the nose and cheek. Add some ears, an eye, a mane and a tail.

Handy tip: Keep looking at the picture you are copying from, but also remember to look hard at what you are drawing, too. Check how it's all coming together and don't panic if you make mistakes. It took me several days to figure out how to simplify drawing a horse and to get it right myself.

crofter's cottage

It's a funny thing, but paintings containing cottages are always in demand from students, so let me show you how to paint one (see page 97) using the Have Some More Fun technique.

you will need

- Paint: Raw sienna, Cobalt blue, Light red, Lemon yellow, Alizarin crimson and Burnt umber
- Brushes: your large (1½-inch) brush, small (¾-inch) brush and no.3 rigger (also an old small brush to use with the masking fluid if you have one)
- Paper: a sheet of 10 x 14-inch (255 x 355-mm) 140lb/300gsm watercolour paper
- Board (16 x 20 inches (410 x 508 mms) to stick your paper on)
- Palette (your white plate or tray)
- Water pot
- Mop up cloths
- Pencil
- Ruler
- Eraser
- Masking tape
- Masking fluid

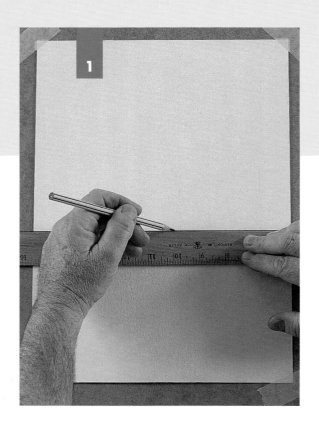

1 HORIZON Using masking tape across the corners, fix your sheet of paper upright (portrait) onto your board. Draw the horizon line almost halfway up from the bottom edge of the paper. Prop up the board.

Just like the people, boats and animals you have learnt about already,
drawing a cottage or any building is easy if you simplify the whole thing.
That's what I've done here, so practise a few cottages ready to use them in
our next landscape. You can create a cottage by using masking fluid to
protect the cottage area before you paint the scenery around it (as we are
about to do) or you can use your White gouache to paint a building onto
an already-painted watercolour landscape.

With your pencil, draw two letter 'V's upside down, about an inch apart.

Join the tips with a straight line and then join three of the end points.

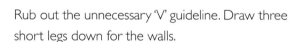 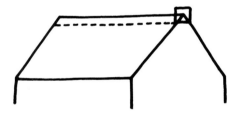

Rub out the unnecessary 'V' guideline. Draw three short legs down for the walls.

Add a small box for the chimney and then adjust the top roof line if necessary to look realistic.

Finish off your cottage by adding a front view to your chimney. Put in a door and windows. They are just two small single strokes done with your rigger for the windows and a longer one for the door.

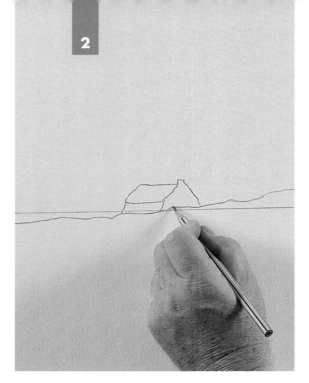

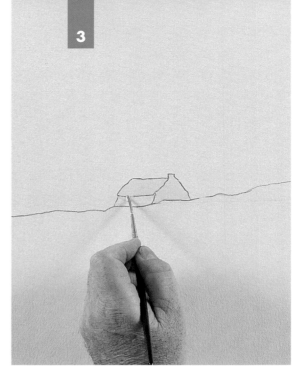

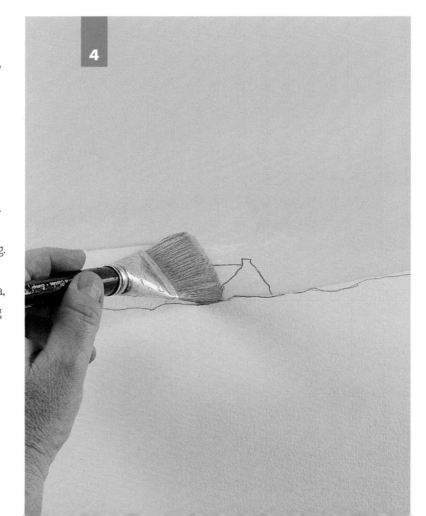

2 COTTAGE Start the picture by drawing a cottage on the horizon line. Draw a tipped line, down across the base of the cottage, to represent the hill.

3 Rub out the horizon line. Be sure to reread page 58 about masking fluid, then, with your rigger, cover the cottage with fluid. Work from the roof down. Ensure the masking fluid is absolutely dry before proceeding.

4 SKY Squeeze out Raw Sienna, Cobalt blue and Light red. Using your large brush, mix some watery Raw sienna. Paint from the top of the page, in broad strokes, over the cottage down to the tipped hill line. Quickly move to page 93!

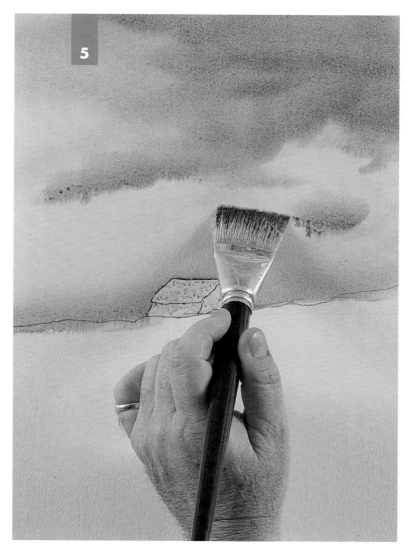

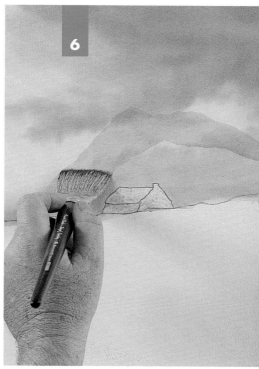

6 MIDDLEGROUND Mixing more Cobalt blue and Light red, paint in a single, pale purple background mountain, brushing over the cottage, and fill this in down to your tipped horizon line. Dry this.

5 SKY Clean your large brush and, while the paper is still wet, mix some Cobalt blue with water and paint in patches from the top of the paper. Quickly add a little Light red to your Cobalt blue to make a purple, wine-like colour and paint in a few clouds. Use your brush horizontally and dab in larger sausages (clouds) of colour at the top of the sky and thinner, smaller ones towards the bottom. Don't fiddle! Dry this.

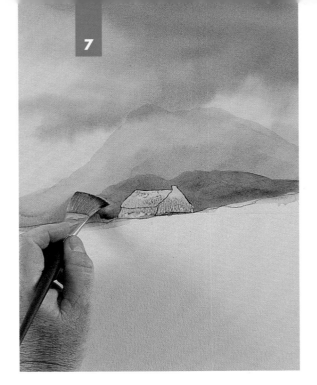

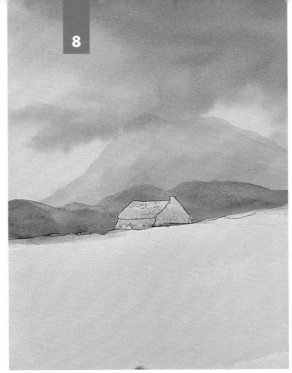

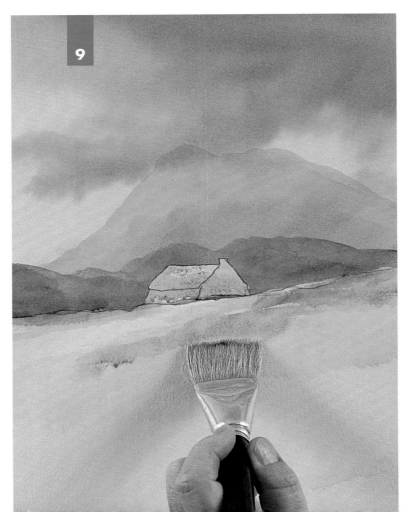

7 MIDDLEGROUND The smaller hills, just behind the cottage, need the small brush and a mix of Raw sienna with Cobalt blue and a tiny bit of the Light red. Use the brush tip, like a chisel, to get a clean edge to your hills and then fill in (painting over the cottage) down to the tipped horizon line. Dry this.

8 FOREGROUND With your large brush and plenty of water, mix together some Lemon yellow with a little Light red. This should be very feint. Paint the whole of the foreground from your tipped horizon line down to the bottom of the paper. Dry this.

9 (*See below left*) Clean your brush. Squeeze out some Lemon yellow, Cobalt blue and Raw sienna. Use your large brush quite dry and mix up varying shades of colour as you go along. Combine all three colours in differing amounts to create a variety of greens and earth tones. For the grass, use the brush corners and horizontally, too, and dab in downward strokes (like you did for the reeds). Take your time and leave some of the paper white to create a shaft of light on the hillside.

10 Slowly build up the dabs of colour. Keep allowing the paper to dry so that you get good dry brush strokes and vibrant colours, and refer regularly to my examples to help you. Be careful that each new layer of paint does not completely cover and obliterate the one you have just painted, and test the colours on a piece of scrap paper to make sure you have the colour you want before you apply it to your painting. Clean your brush and add a few downward dabs of neat Light red. Dry this.

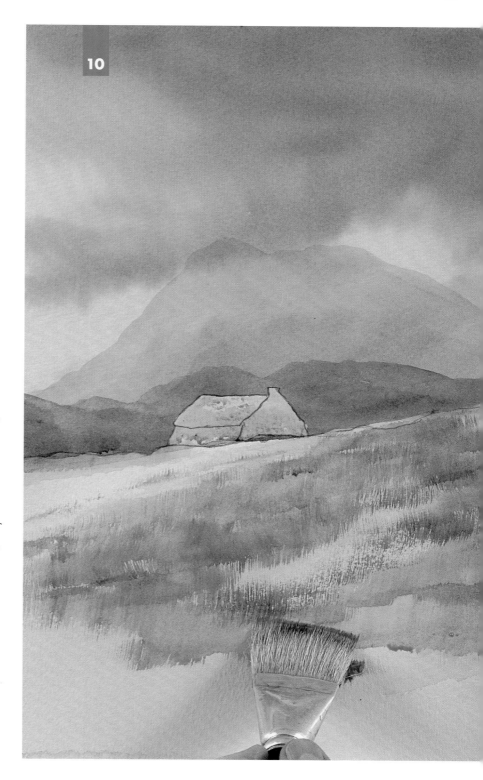

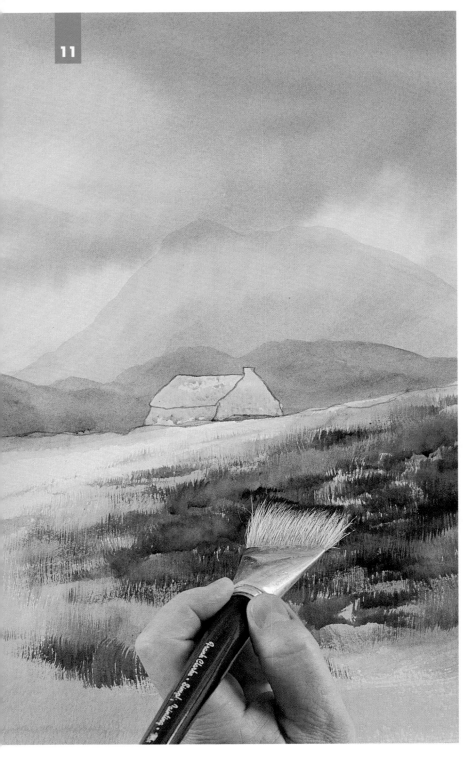

11 To paint the heather in the foreground, mix Alizarin crimson with a little Cobalt blue for a deep purple and stipple this in. Dry this. Finally, use some Burnt umber sparingly on a dry brush to create some reeds here and there.

12 COTTAGE Ensure all the paint is completely dry then remove the masking fluid with a clean finger or eraser. Rub gently from the outside edge of the cottage, in towards its centre. Lift off the lump of rubbery masking fluid and you'll now have a lovely white cottage.

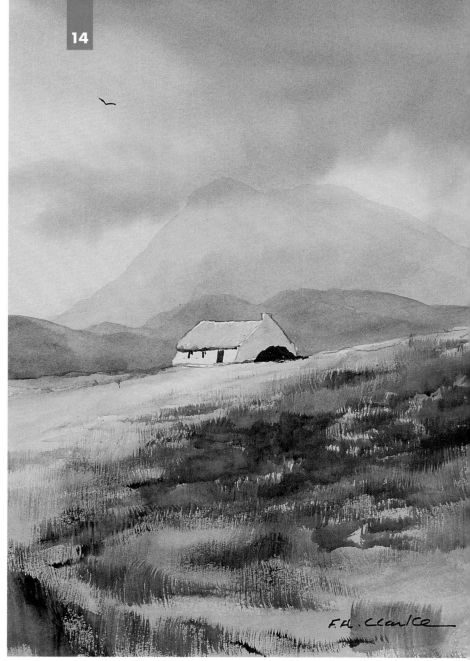

13 For the thatch, paint the roof using your rigger and a mix of Raw sienna with a tiny bit of Cobalt blue. While it's wet mix up some Burnt umber and paint a thin line under the eaves. The paints mingle to give a soft shadowy edge.

14 The light is coming from the left, where the sky is brightest, so the right end of the cottage is in shadow. Make a reasonably light (watery) shade of the darker sky colour – Cobalt blue mixed with a little Light red – and paint the side of the house. Dry this. The turf rick beside the cottage is a mix of Burnt umber with a touch of Cobalt blue. With your rigger, draw its shape, then fill it in. The door and windows are the same colour, so paint in a long rectangle, from the eaves almost down to the ground. (Don't be tempted to make the door too wide.) The window is a single, short stroke straight down with the brush tip. Well done! Don't forget to add your bird and sign your painting.

smoke *and* **perspective**

Creating Smoke

Paint your landscape complete with a cottage. When the picture is
absolutely dry, take your no.3 rigger brush loaded with clean water and
use it to wet your painting where you want the smoke to be. Then,
with a piece of paper tissue, blot off the water. You will remove the
paint underneath it. The paler area left on your painting now looks
like a trail of smoke.

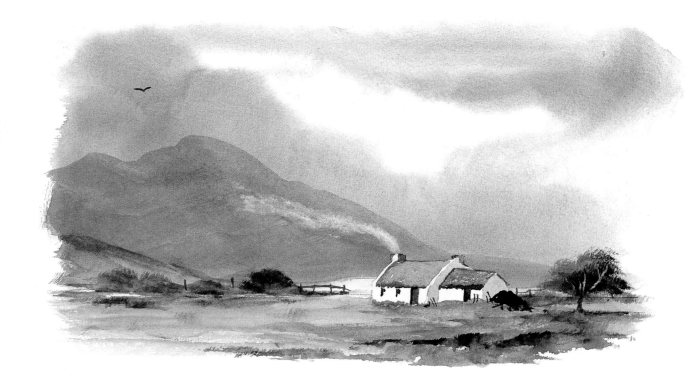

Handy tip: Don't overdo the water. You want the chimney smoke to look realistic
and wispy, not like the house is on fire!

Understanding perspective

Using the horizon line as a guide, we can create various angles and learn about perspective and convergence. Don't worry, I'm going to simplify everything to show you that perspective is easy when you know how!

Draw a horizon line straight across the page. From the left end draw a further two lines *above* this. Draw in your row of houses within these guides to get the impression of looking up at the houses.

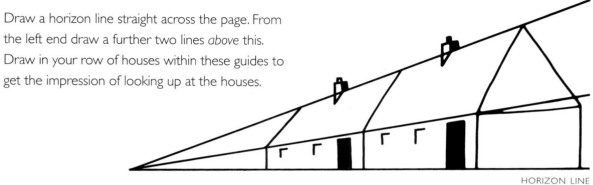

HORIZON LINE

Draw a horizon line straight across the page. From the left end draw a line *above* and one *below* this. Draw in your row of houses using the horizon line as the bottom of the rooves to give the impression of looking directly at the houses.

HORIZON LINE

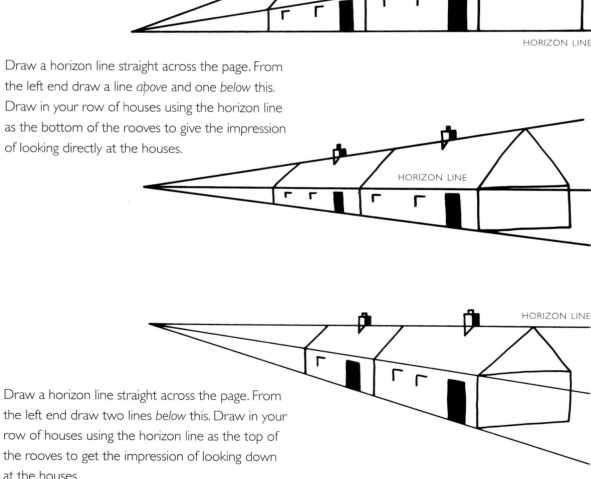

HORIZON LINE

Draw a horizon line straight across the page. From the left end draw two lines *below* this. Draw in your row of houses using the horizon line as the top of the rooves to get the impression of looking down at the houses.

rushing stream

Flowing water(see pages 108–109) always has a fascination for artists. (Notice I'm now calling you an artist!) Make sure you always have the water flowing towards you, and remember to read the steps right through before you start painting.

you will need

- Paint: Raw sienna, Ultramarine blue, Lemon yellow and Burnt umber
- Brushes: your large (1½-inch) brush, small (¾-inch) brush and no.3 rigger
- Paper: a sheet of 10 × 14-inch (255 × 355-mm) 140lb/300gsm watercolour paper
- Palette (your white plate or tray)
- Water pot
- Mop up cloths
- Pencil
- Ruler
- Eraser
- Board (16 × 20 inches (410 × 508 mms) to stick your paper on)
- Masking tape

1 HORIZON Using masking tape across the corners, fix your sheet of paper lengthways onto your board. Draw the horizon line about 3 inches (7.5 cms) up from the paper's bottom edge. Prop up your board.

2 With a pencil, sketch in guide marks for where your rocks and water will be (see *above right*). Don't panic! Look carefully and you'll see it's only a collection of shapes and lines. Keep the bases of the rocks and right riverbank

parallel with the horizon line, and keep it simple!

3 SKY Squeeze out Raw sienna and Ultramarine blue (the two-minute rule now applies). With the large brush, mix watery Raw sienna and sweep broad strokes from the top of the page down to just above your pencilled rock line. Clean your brush, mix the blue and paint the sky leaving cloud gaps. Dry this.

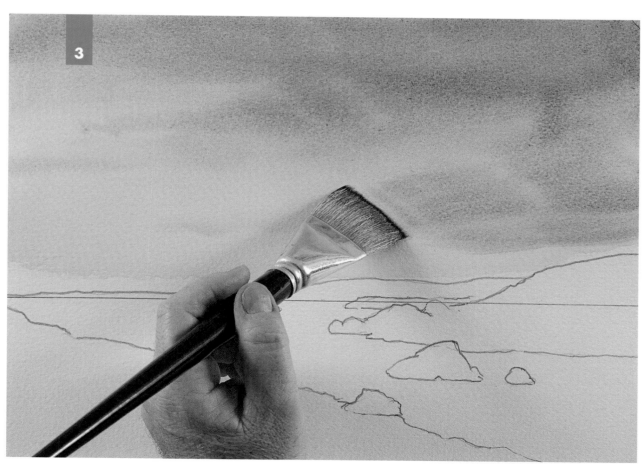

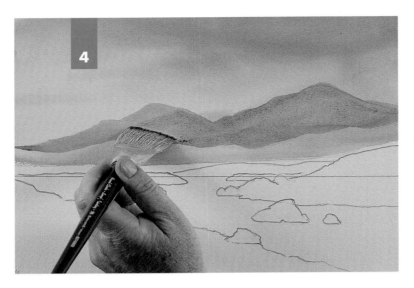

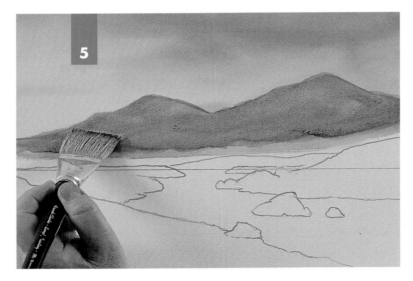

4 MIDDLEGROUND Using your large brush with a mixture of Raw sienna and Ultramarine blue, paint in your letter 'M' for the mountains.

5 While it's still wet, add a little more Raw sienna to the brush and as you paint, down the mountain to half an inch above your rock horizon line, gradually it will turn to green and then to browny-yellow. (Don't fiddle too much, just dab in the paint and the colours will mingle automatically.) Don't go below the rock line. To indicate that light is coming from the left, paint in a further patch of blue on the right side of both mountains to form a shadow.

6 At the base of the mountains, paint a strip of Raw sienna using the small brush.

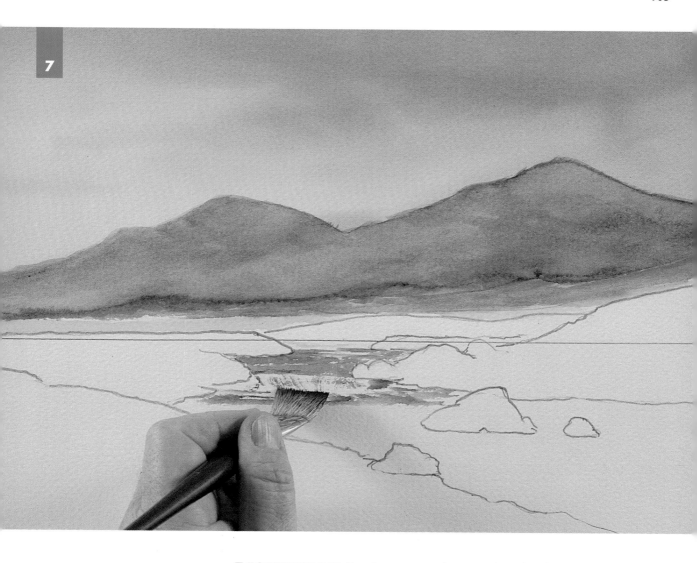

7 FOREGROUND For the water, use your rigger with sideways strokes and work down the page. Add a touch of Raw sienna to get a bit of variation in tone and look carefully at my example. With the same mix of paint and with the corner of an almost dry small brush put in a few feathery downward strokes, keeping as much of the white of the paper as possible, to represent the small waterfall.

8 FOREGROUND With the same colour fill in the water up to the edge of the rapids. Paint side to side with the horizontal tips and corner of the small brush. The rapids need an almost dry brush to trail in thin lines.

9 Complete water with darker blue. Horizontal strokes will help flatten the river out. Leave white foam flecks. Dry this. Use a mix of 10% Raw sienna, 80% Lemon yellow and 10% Ultramarine blue on the small brush for the banks.

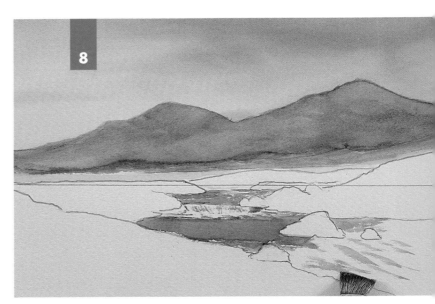

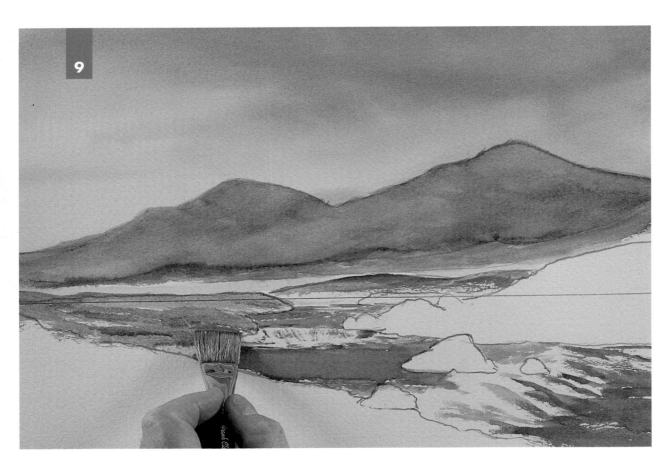

10 Touch here and there with a darker shade of paint to get a mottled effect on the central and left riverbanks. The right bank is lighter, as the sunlight hits it, so use less Ultramarine blue in your paint mix. Leave a few flecks of white.

11 Where the banks meet the water, use a little Burnt umber to lay a few horizontal shadows around their bases. Touch a little on the banks themselves, too. Use the rigger if it's easier.

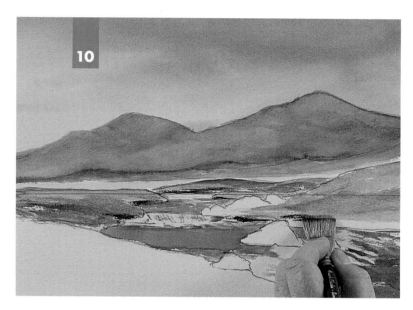

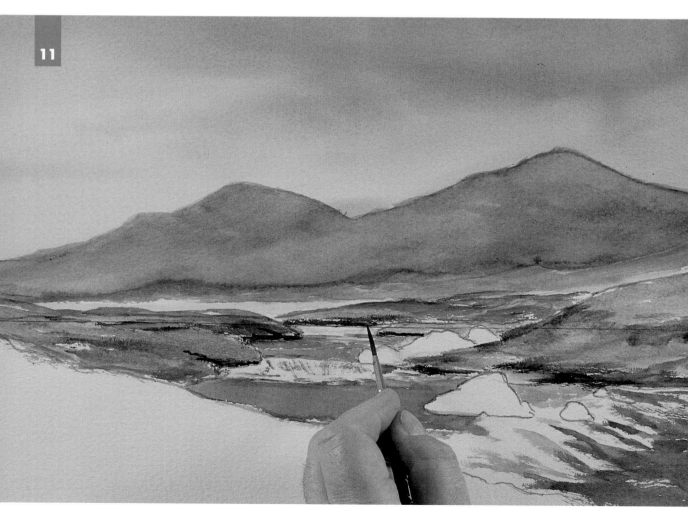

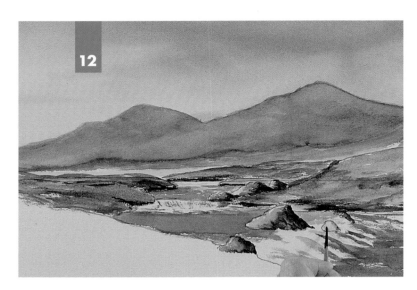

12 FOREGROUND The rocks are Ultramarine blue mixed with some Burnt umber. Start from the top of the page and work down, using your rigger. Paint from light to dark, applying a pale paint coat to all the rocks and leaving a few patches of white on their sunny (left) sides. Now, load more paint with less water on your brush for a darker shade and on the right sides of the rocks put in the shadows.

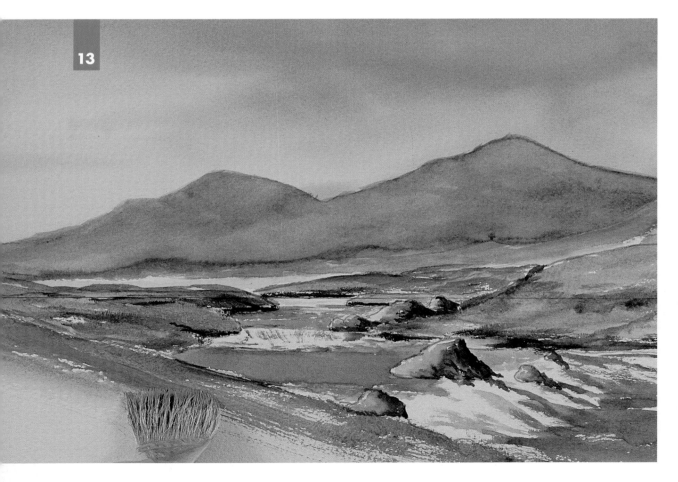

13 (*See below left*) Use your large brush fairly dry with a mix of Lemon yellow and Ultramarine blue to give a strong green. Paint the riverbank nearest you using sweeping strokes. Leave some white flecks of paper. Add a tiny bit more yellow as you go down to get a variation in shade.

14 Clean and dry your brush then use Burnt umber and short downward strokes to create some reeds and dry grasses, especially along the riverbank for contrast with the water.

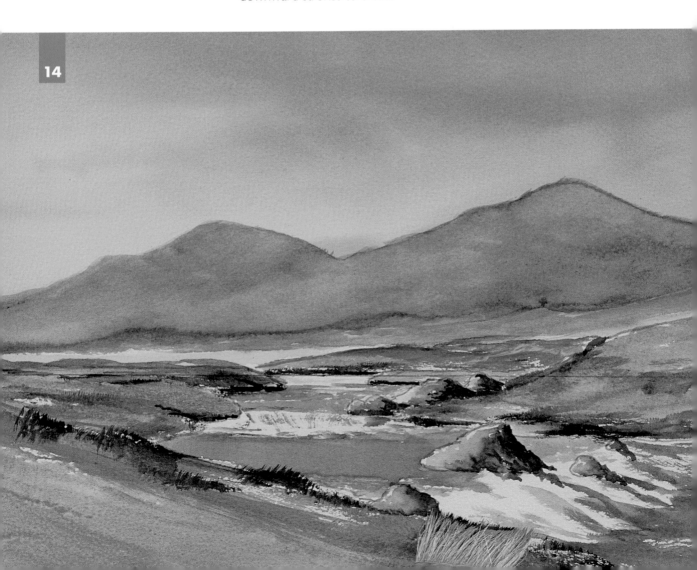

14

RUSHING STREAM

Put in your bird and sign your painting. Often the temptation is to overwork areas of a picture, especially the foreground, and to keep fiddling with a small brush. Dont! Keep it simple. You can always paint the same scene again and again, varying parts of the picture and adding your own bits and pieces – and these paintings here are just a start. I hope you will go on to paint many more beautiful pictures ... remember that whatever landscape or still life you are painting, if you use the Have Some More Fun/Horizon Sky Middle and Foreground technique you can't go wrong!

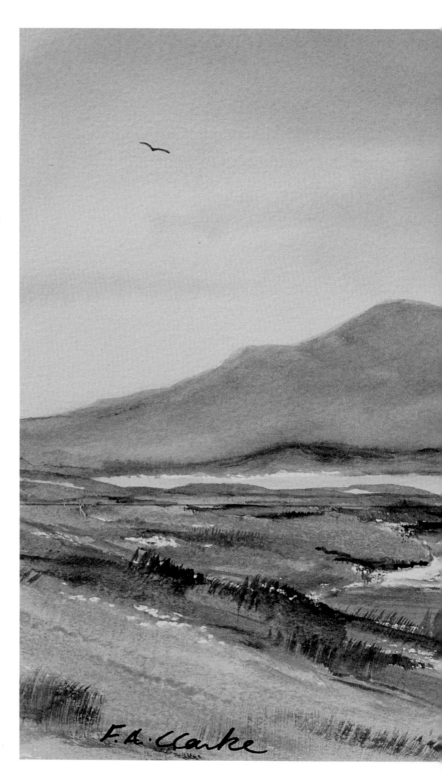

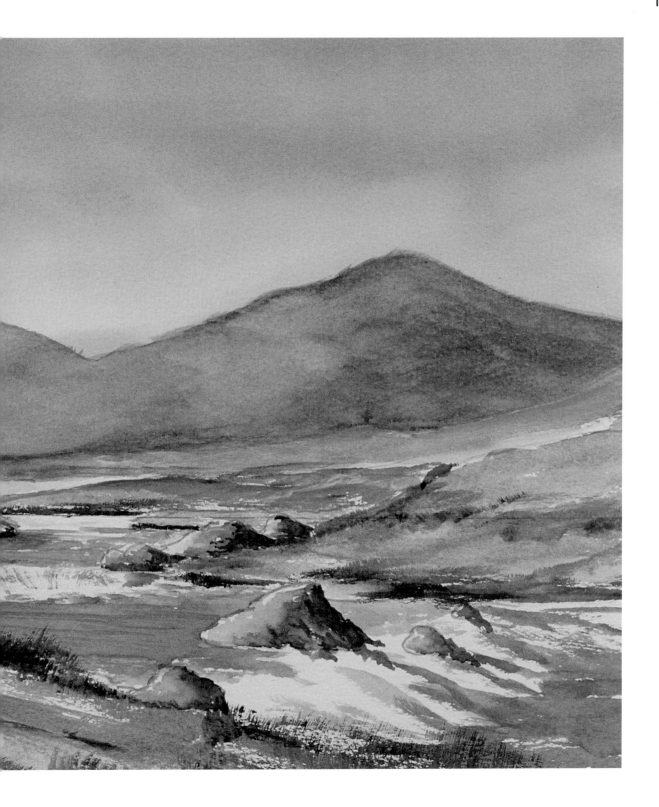

drawing and painting **bridges**

The intention of this book is to get you to paint a basic landscape, which I would describe as your backdrop. You can then add the special features such as houses, carrot-people, boats, animals, etc. You have now painted a rushing stream and perhaps next time you could incorporate a bridge. With this in mind, let me show you how to draw a bridge. Of course, once again, we simplify it.

Draw a letter 'U' and then turn the paper upside down to get the inside arch of a bridge.

Draw a slightly curved line over the top of the upside down 'U' and you'll see that we have a basic bridge shape.

Handy tip: Even if you don't take your paintbox with you when you go out, why not take a pencil and notebook. Pick a subject and see how simple you can make it. Remember a mountain range is reduced to just the letter 'M', a person is a carrot and a boat is a figure eight. Anything can be simplified to be drawn easily, it just takes a little time to look hard at it and find a way to make it simple.

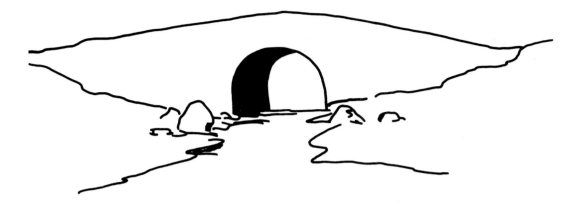

Darken the underside of the bridge. Now add the embankments and rocks in the foreground. Don't forget a water line under the bridge to mark the horizon beyond.

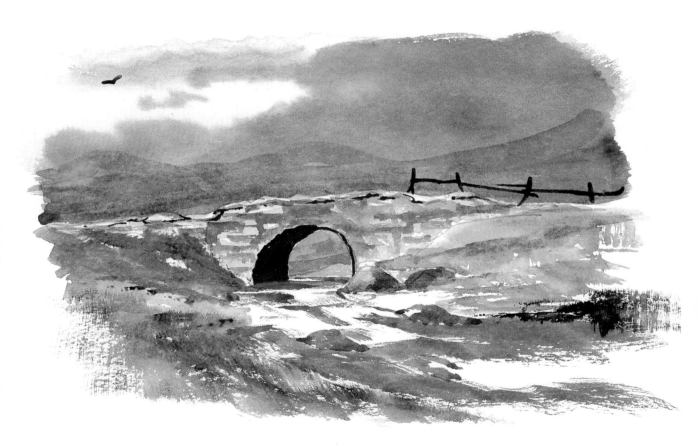

Framing

I hope you've enjoyed learning to paint and you now have your pictures adorning the walls of your home. I make one rule with all my students that, apart from signing their paintings, they must frame them. If you've taken all that time and effort to paint something isn't it worth finishing it off properly with a frame? Framing will improve it 1000% and watercolours particularly can really be brought to life.

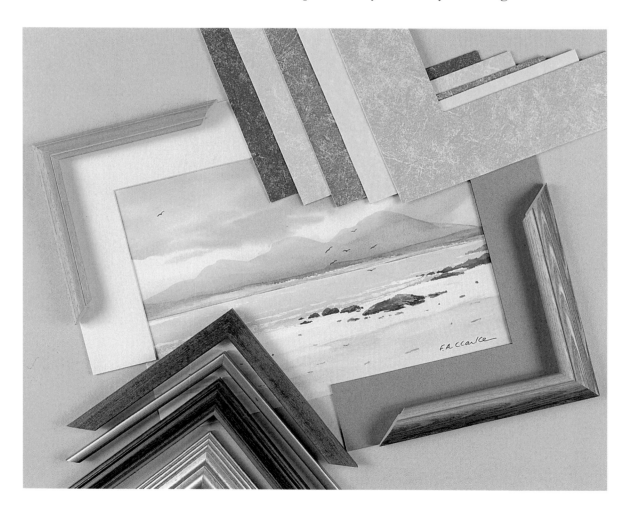

To frame a painting you will need a mat or mount – a piece of card with a hole half an inch (1 cm) smaller than your picture. Artshops sell these ready-cut, and they serve to cover the messy bits around the edges of your picture. Bear this in mind when you are signing a finished painting and sign it a little in from the edge, otherwise you may cover your signature with the mount when you frame it.

Your local frame shop can be very helpful and my advice is to take your painting along and get them to help you. It is not necessary to purchase expensive, ornate frames for watercolours and I always think that simple wooden ones look best. It's a good idea to buy a frame that you can use for other pictures, then you can change your masterpiece to suit your mood or match the seasons. (I like to hang a winter scene at Christmas.) Choose a neutral or light-coloured mount, with a 2-inch (5-cm) surround … there I go, doing the framer's job!

You can, if you like, make your own frames. Perhaps someone in the family is a budding carpenter? If this is the case, your local DIY store will have moulding, backboard and glass, and you can buy a small mount cutter to cut your own, or try using a small, sharp knife. I must admit that I tried it and was useless. Maybe because no one showed me how! Anyway, I buy my frames made up but you can make your own choice. As I've already said: please frame your pictures. You will be amazed how much framing improves them.

Handy tip: I always keep a spare mount and when I'm painting I often place it over the unfinished picture just to see how it is coming along. It's really encouraging and I find doing this helps you take a moment to stand back and have a good look at what you are creating.

Painting outside

One of the greatest problems to confront the budding artist when painting outdoors is knowing where to start and finish. Because the view you are looking at is so large (and you can't possibly paint it all) you need to section off an area that you can paint. To help you with this problem I will show you how to make your own viewfinder.

Making a viewfinder

Get a large piece of cardboard. Use a ruler to mark and cut two 'L'-shapes about 8 inches long, 8 inches high and 2 inches wide (20 x 20 x 5 cms).

To use your viewfinder, hold the two pieces together to form a square with a hole in the centre. Hold it out at arm's length and scan the landscape until you find a pleasing part of the view you think would make a good painting. The viewfinder will help blot out the surrounding area so that you can focus your attention only on what's within the square. You can adjust the size and shape of the view hole by moving the card pieces, too. Also, the nearer you hold the viewfinder to your eyes, the bigger the area you can see, the further from your eyes the smaller the area.

There is nothing complicated about choosing a view. When you are looking around, you will often be drawn to a focal point or area because there is something there that interests you. It might be a building or a particular tree, hill, lake, boat, etc. Whatever it is, if you like it and want this to be the subject of your painting, then that's a good enough reason to get painting it!

Handy tip: Remember the brush is mightier than the bulldozer so if there is something within the picture that you don't like, leave it out!

'Composing' a picture

Once you have used your viewfinder to find a view you like best, or when you have arranged your bowl of fruit or vase of flowers to your liking, you then need to think about how to arrange your 'view' on your paper ... i.e. where to position things. The experts call this 'composing' a picture. Once again, there is nothing mysterious about how to do this if you remember a few simple points:

- Don't place your main subject dead centre of the picture as it looks odd. In still life pictures particularly, set the vase slightly to the left of centre.

- Remember the further away something is, the higher up the page and the smaller it becomes.
- When you paint distant things, like your mountains, make them paler and it will immediately make them seem far away.

- If you have trees on both sides of your picture make sure they are not both the same height and size.

- Roads, tracks or lanes converge – they are wider towards the bottom of your page and get thinner as they move up or across into the distance.

- It is not necessary to put everything you see into your picture, as I've done here. It gets too cluttered so simplify what you see by picking out the overall shape and colour of an area. Also, paint as much as you can with the largest brush possible to stop you fiddling with detail.

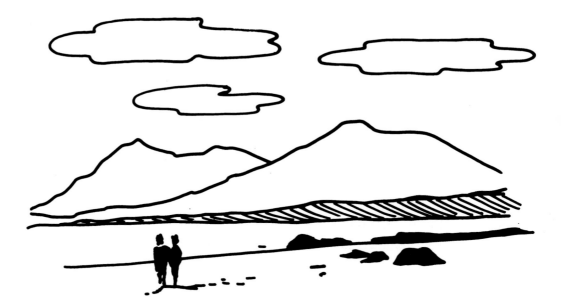

- When painting skies remember to use big sausages (clouds) of paint at the top and smaller, thinner sausages nearer the horizon line as they are further away.

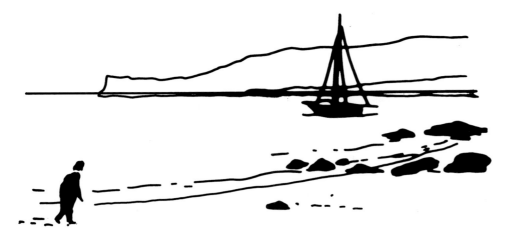

- If you paint a boat on the right side of your paper, have it sailing into the picture (i.e sailing from the right towards the centre of the paper). The same applies to putting a boat on the left of your picture, sail it in towards the centre. If a boat is sailing away to the edge of the picture, it seems to be sailing *out* of the picture and will take the viewer's attention with it!
- The same applies to people. If you have a person close to the side of your paper, make sure they are walking into the picture, not out of it.

- Try not to cut the page in half horizontally. Put your horizon line above or below the halfway point and avoid painting unbroken fences, hedges, roads or streams right across the page from one side to the other. If you do, it stops people looking beyond that 'line' you have created on the page.
- The most important point of all is: ignore the self-appointed critic. We all meet them. My advice is to ask them if they themselves paint. When they reply 'No', as they usually do, tell them what great fun they are missing. This usually has the effect of silencing them. It is very seldom that you hear one artist criticize another. Painting is about enjoying yourself, so don't let others put you off. Have Some More Fun is not only your painting technique, it should also be your motto.

Skies

When I am asked what do I enjoy most about watercolours, my immediate answer is painting skies. This may seem unusual, as you have probably found that skies are the least easy part of watercolour painting (notice I said least easy, not difficult). Here are some hints to help you enjoy painting skies as much as I do.

The technique I use for skies is called wet into wet, which in plain language means wetting the paper with clean water and then applying the wet paint. The most important thing to remember when painting skies is that you always only have about two minutes to complete the sky. The reason for this time limit is, as you may have already discovered, that after two minutes the paper starts to dry and the paint begins to set. If you keep fiddling with the sky the brush will leave streaky marks, so remember, two minutes and stop.

Watercolour paper has two sides so if your sky does not turn out as you want, turn over and start again. It has only cost you two minutes. I can't tell you how often I have done this. In fact many of my best efforts have a failed sky on the reverse side. My motto is get the sky right and the rest of the picture will follow.

When you wet watercolour paper you turn it into blotting paper so when you add the paint it spreads. It's a little bit uncontrollable but don't try and fight or stop it as this is part of the fun. Every sky you paint will be unique and, now that you've had some practice painting, you've probably noticed that when watercolour paint dries, it lightens. So you need to be quite bold (as well as quick) when you're painting your skies. The best advice I can give you at this point is to experiment for yourself by painting lots of different skies and see the results for yourself. The more the merrier.

Here are some examples of my skies to try:

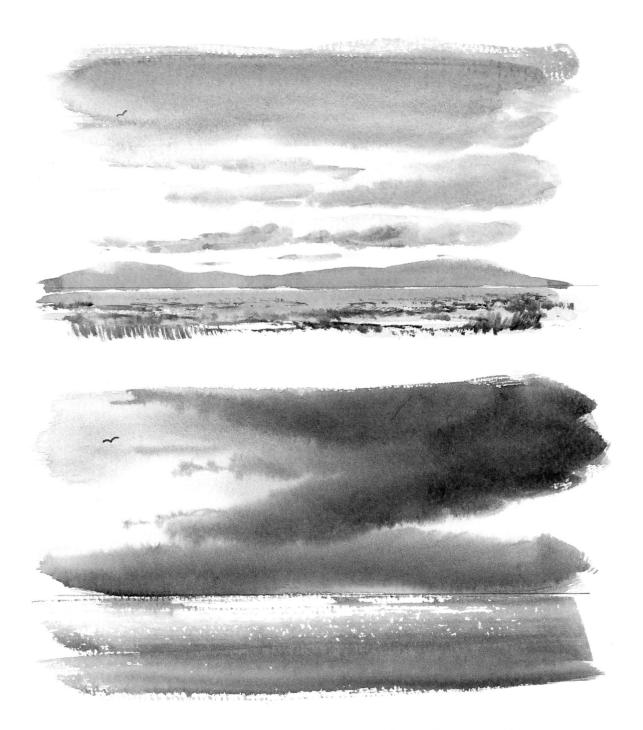

The colours used in both of the paintings above are Raw sienna, Ultramarine blue and Light red. As you can see, very different effects can be achieved using the same colours.

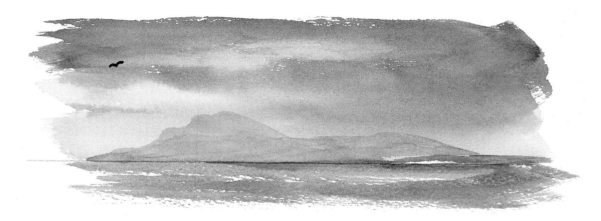

Colours used: Alizarin crimson, Lemon yellow and Cobalt blue.

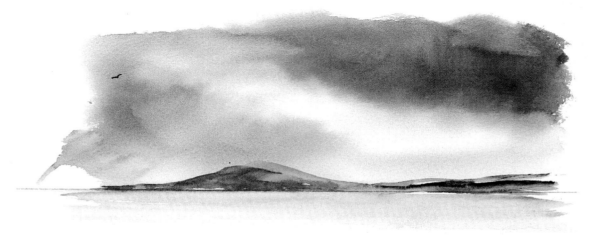

Colours used: Raw sienna and Payne's grey.

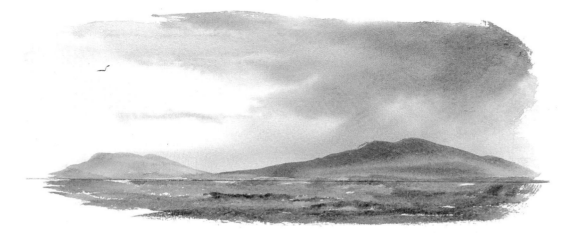

Colours used: Raw sienna, Cobalt blue and Alizarin crimson.

Laying a wash

Watercolour paint is transparent so, when it is mixed with water, it can be washed in a thin layer onto your paper. This is called laying a wash and you have already been doing this when you have painted your skies, but I wanted to now give you the technical term for it. I also wanted to point out that it is possible to apply many washes, one over the other, to get a particular shade of colour you require and that washes can be used for painting other things apart from skies.

For our skies we needed the paper to stay damp so that the the colours would blend into each other and run to give us a soft edge to our clouds, but for laying any other wash there is one golden rule: the first wash must be completely dry before you attempt to paint the second one over it. This rule applies every time you put one wash over another. Forget it and you ruin your picture. A hair dryer helps to speed up the drying process.

To lay a wash successfully you should start with your lightest shade and build up the colour bit by bit, laying the darker wash over the light one. Let me show you how to paint a mountain range using washes:

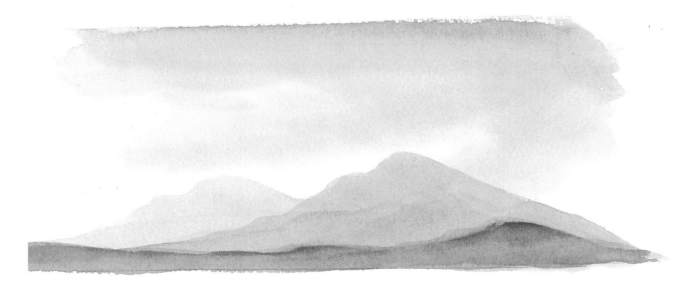

1 Before you start your mountains, you first need a sky, so squeeze out some Raw sienna and Cobalt blue. Using the large brush and the two-minute rule, lay a wash of watery Raw sienna over the page. Clean your brush and, while the paper is still wet, paint from the top down with Cobalt blue, leaving some areas of Raw sienna showing to represent the clouds. Dry this.

2 To create the mountains, use the same colours as you used for the sky and mix the Cobalt blue with a tiny bit of the Raw sienna. Paint in your 'M'-shaped mountains in the distance. Dry this.

3 Once dry, and using the same mix of paint, lay another wash over just one of the mountains. The double density of paint will automatically make this mountain darker and it will appear closer. Dry this.

4 (See previous page) Now put in a smaller hill (which will appear closer still because it is even denser) by adding a touch of Light red to your mix of Cobalt blue and Raw sienna and painting a third wash in the foreground.

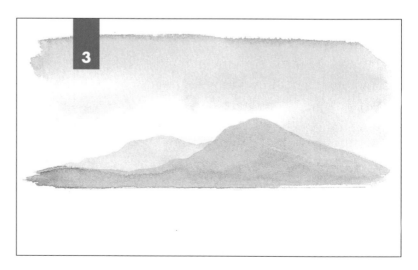

Colour mixing

It is not by mistake that I kept the colour mixing section until the end of the book. It is my firm belief that we must paint pictures first, before we get bogged down with the technicalities and complications of colour mixing.

I attended one course of art classes where we started with the colour chart. Sometimes it's called a colour wheel, but whatever its name, I spent my first four weeks mixing paint and didn't paint a single picture. I have to admit I found it boring and so I have not inflicted the subject on you until now. Of course learning to mix colours is important, but what the budding artist needs first is to be encouraged and convinced that he or she can paint. If you have followed the step-by-step paintings and read this far in the book, you know you can paint and have proved it to yourself and others, so now is the right time to talk about colour mixing and colour charts.

Making a colour chart

There are three primary colours: red, blue and yellow. By mixing combinations of any of these three colours together we can, in theory, produce every other colour which exists.

A colour chart shows us what colour we get when we mix two colours together. Every artist makes their own chart eventually as it acts as a quick reminder – a reference point – about how you created a particular colour in the first place. It saves you time as you don't have to experiment and search for that colour match all over again; a record of the colours you need to mix is there on the chart.

I am sure you have realized, as you have been painting, that it takes more time to get the right colour than it does to apply that colour to the picture. In fact I always maintain it takes about 90% of your time

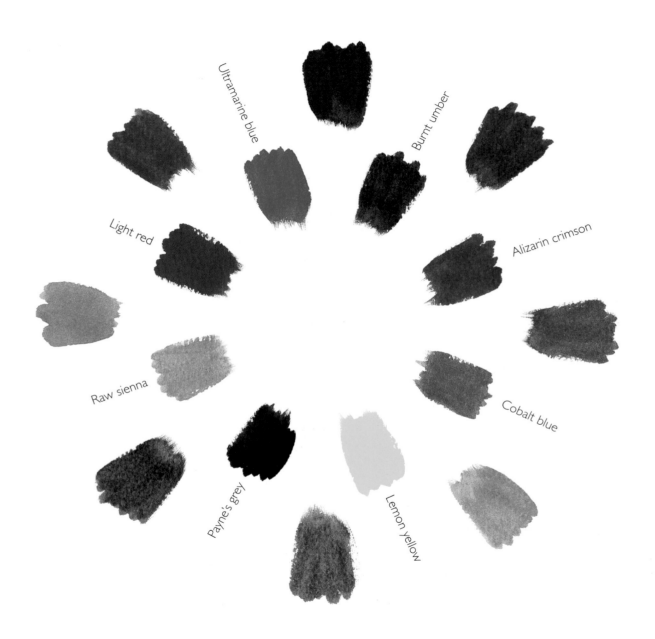

Ultramarine blue

Burnt umber

Light red

Alizarin crimson

Raw sienna

Cobalt blue

Payne's grey

Lemon yellow

to mix your paint and only about 10% to put it on your paper. So you can see the advantage of having a colour chart of your own, to help and guide you.

Now, what I don't want you to do is to spend the next three days making up a colour chart. (The purpose of this book is to show you how to paint, not to bore you!) Take your time and build a colour chart up slowly, adding new colour mixes as you discover them when you're painting.

Here is the basic colour chart put together using the eight watercolours we have used in this book. All you do is paint a patch of each of the eight individual colours, as they are from the tube, in a circle or, if you prefer, down the side of your paper. Then, in turn, mix the Alizarin crimson with the Cobalt blue (the colour next to it already painted on your page) in equal proportion. Paint the resulting purple colour in a block between the two original colours mixed. Now when you refer to your paint chart you will be able to see at a glance the colour you get if you mix your Alizarin crimson and Cobalt blue together. Now clean your brush and mix the next two colours from your original eight – Cobalt blue and the Lemon yellow – together. Paint a block of the resulting green between the two original colours. Clean your brush and continue mixing one colour with the next until you have eight new colours lying beside your original eight.

There are of course hundreds of colours you can make from your original eight. It depends on which two you add to each other, and also whether you add a third colour to that mixture, too. The colour mix alters when you add more of one colour and less of another. And remember, a shade of colour can always be lightened by adding more water.

Experiment as you paint and keep your colour chart handy so that you add to it if you discover a new colour mix. It really will save you having to search for the right mix, next time you want to use it. This is what every artist does ... yes, you *are* an artist!

Handy tip: Experiment a little and try to mix as many different greens as you can. You'll be amazed at how many you can get and it's a very useful exercise for future landscape paintings.

And finally ...

As we have now come to the end of the book I hope you have realized that when I said anyone could paint, I was stating a fact. I also hope you have made use of the lessons and are now the proud owner of some wonderful paintings, which are framed and hanging on your walls – and the walls of your friends' and relatives' houses!

When I started to paint I gave everyone a picture. Don't underestimate the importance of your effort. You can't give a friend or relative a nicer gift, so I am told. Please keep painting. It is a great hobby and is one of the most therapeutic pastimes you will possibly ever discover. It can give hours of pleasure to anyone who tries and there is no age limit to starting. I have had many older people attend my classes. In fact, a friend of mine who is over ninety years old, recently told me he was going to take up portrait painting. You see, the secret is ... painting (of any sort) keeps you young. Many artists, poets and writers live to a great age and one reason for this could be that being creative keeps your brain alive and active. Believe it or not, it has been proved that in schools in America where art is included in the school curriculum, the students were, on average, 20% better in every subject they studied. So, painting is obviously mind expansive but, more important, it is great fun.

So till we meet again remember, Have Some More Fun!

For information regarding my painting classes or if you have any difficulty obtaining the materials we use in this book, please write to me at:

Frank Clarke or visit my website:
P.O.Box 3312 www.simplypainting.com
Dublin 6W
Ireland
Freephone: 0800 0182541